MOMENTARY

The Art of Ilya Kuvshinov

MOMENTARY
The Art of Ilya Kuvshinov

Author: Ilya Kuvshinov
Editorial Design: Tomoyuki Arima (TATSDESIGN)
Translation: Erica Williams, Taishi Miyaji (Paper Crane Editions)
Editor: Keiko Kinefuchi
Cooperator: Masayuki Kobayashi, Fatima Camiloza

Publisher: Hiromoto Miyoshi

PIE International Inc.
2-32-4 Minami-Otsuka, Toshima-ku, Tokyo 170-0005 JAPAN
comic@pie.co.jp

ISBN978-4-7562-4875-6 (Outside Japan)
Printed in Japan

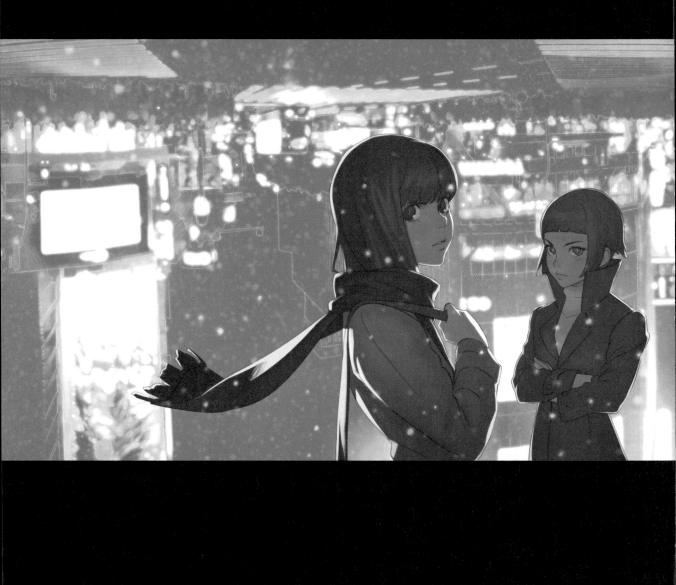

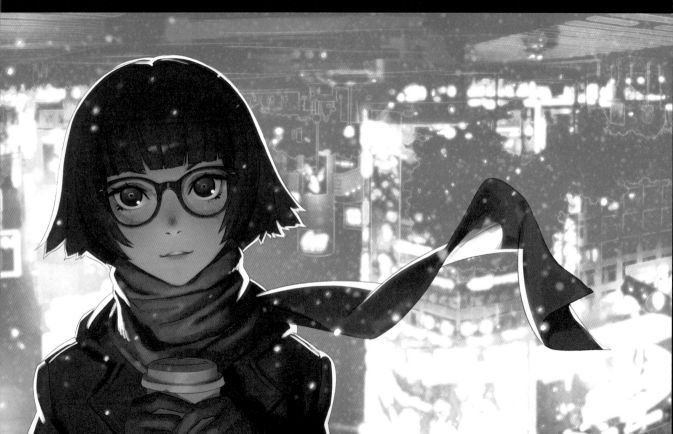

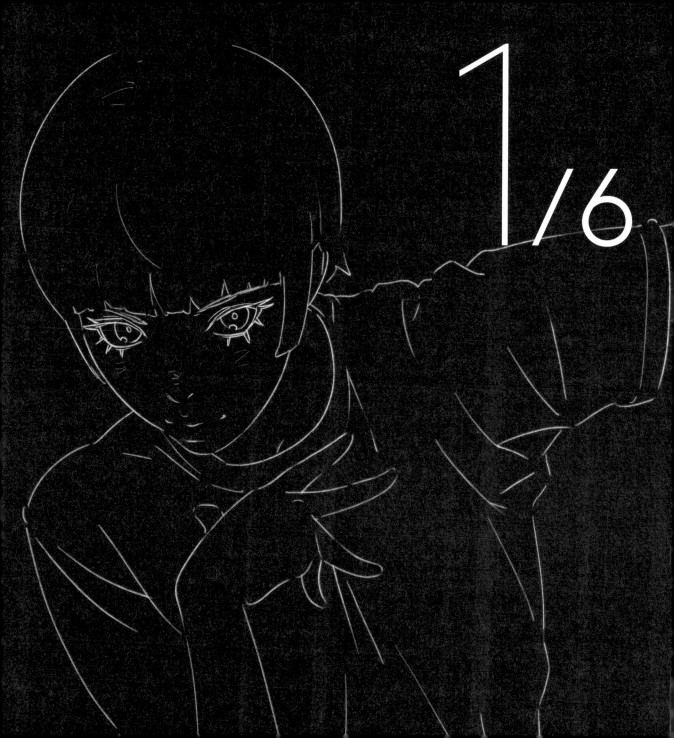

こんにちは、イリヤ・クブシノブです。私はロシアで生まれ育ったイラストレーターで、今は日本で活動しています。

本書は、この三年間に描き上げたイラストの中からお気に入りの作品を選んで掲載しています。気づいた人もいるかもしれませんが、私の作品には欠かすことのできない要素があります。それは正方形のフォーマットです。正方形のフォーマットは人物の感情をとらえるのに最適で、見ている人の視線を顔の表情や手などに集中させることができます。そしてそれは、表情などからより深く絵について理解してもらえるということにつながります。正方形のフォーマットに

することで、人物の表情やしぐさが言葉よりも多くを語ってくれます。

モスクワにいた頃はゲーム制作会社で働いていました。そこでは16:9（もしくは4:3）のフォーマットを使っていました。16:9のフォーマットは動きを表現したり、ストーリーを語ったりするのには適しているのですが、私がイラストで表現したかったことには向いていませんでした。私が描きたかったもの、それは人物の表情の変化や何気ないしぐさをとらえた「特別な瞬間」です。この本の中にあなただけの「特別な瞬間」を見つけていただけたら嬉しいです。

I'm Ilya Kuvshinov, an illustrator born and raised in Russia, who now resides in Japan.

This book features my favorite illustrations that I've completed over the past three years. You may have noticed something which is integral to my art style: the format. Using a square format is the perfect way to capture people's emotions. Composed of fixed "points of interests", such as the face or hands, it invites the viewer to focus on the facial expressions and have a deeper appreciation for them. These elements of

the artwork sometimes speaks louder than words.

Back in Moscow, I was working at a game production company where we used 16:9 (and 4:3) format. This format was ideal for expressing movement and storytelling but it didn't suit what I wished to express in my illustrations. My goal was to capture a "special moment" by highlighting facial expressions or casual gestures. I would be delighted if you could find your own "special moment" when browsing through my book.

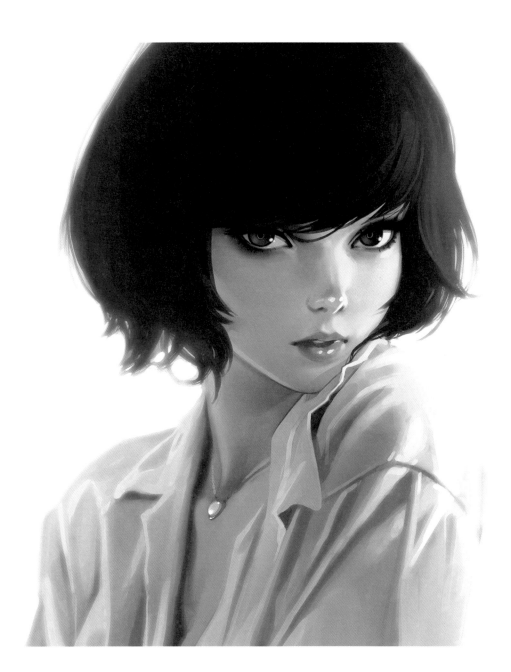

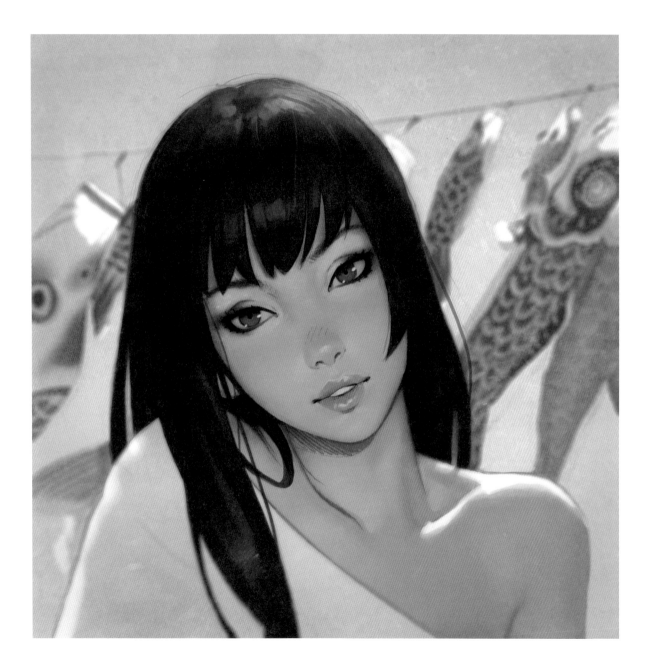

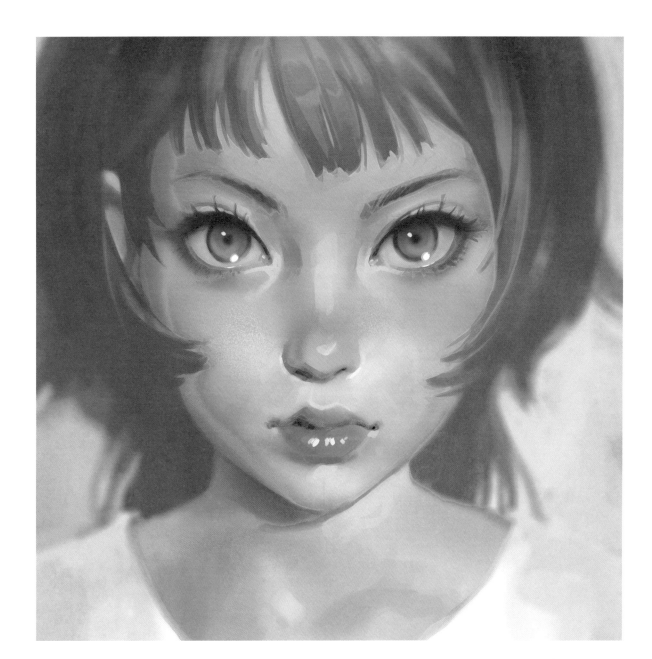

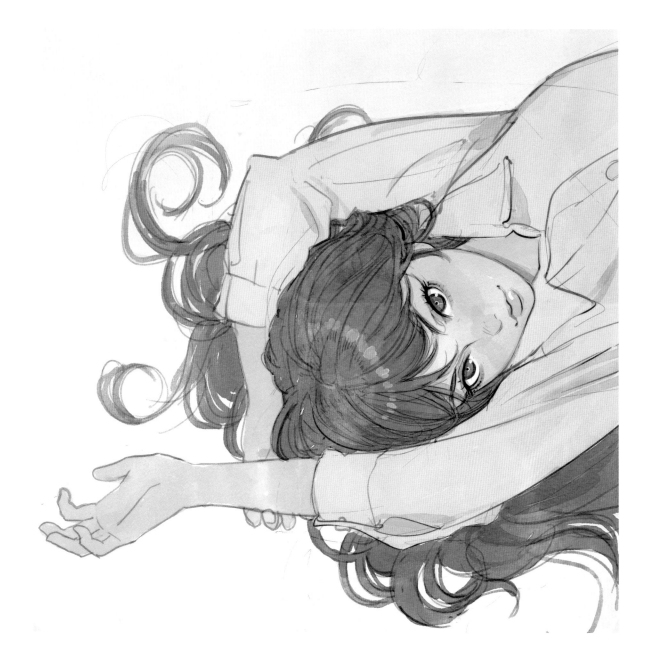

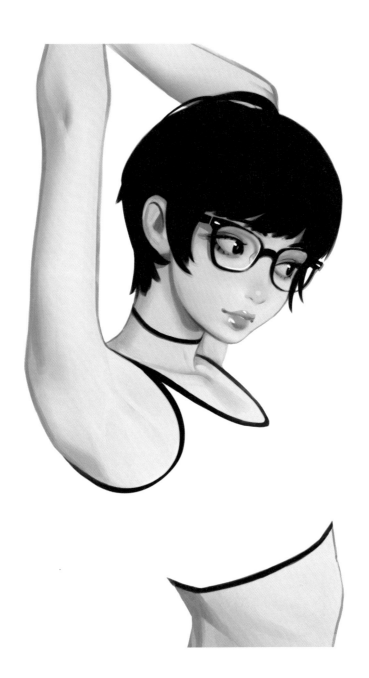

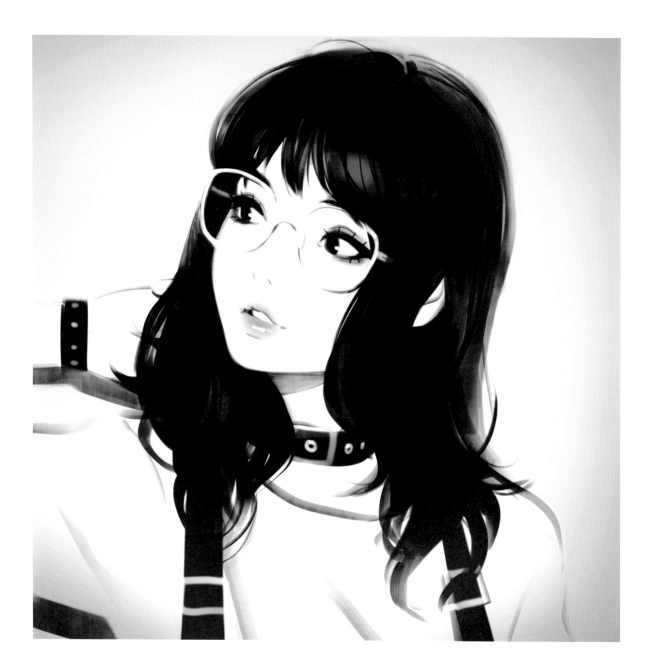

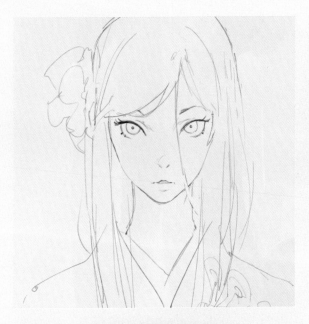
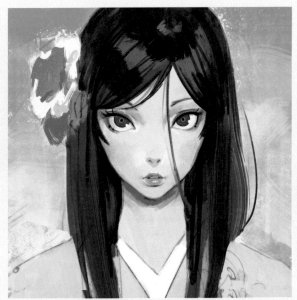
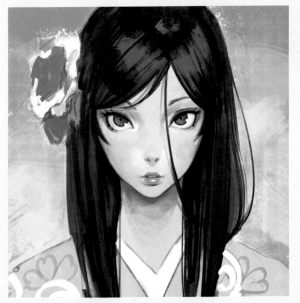
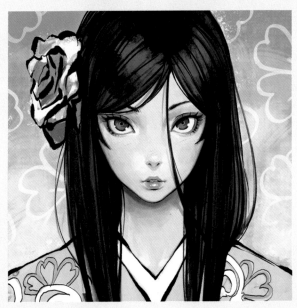

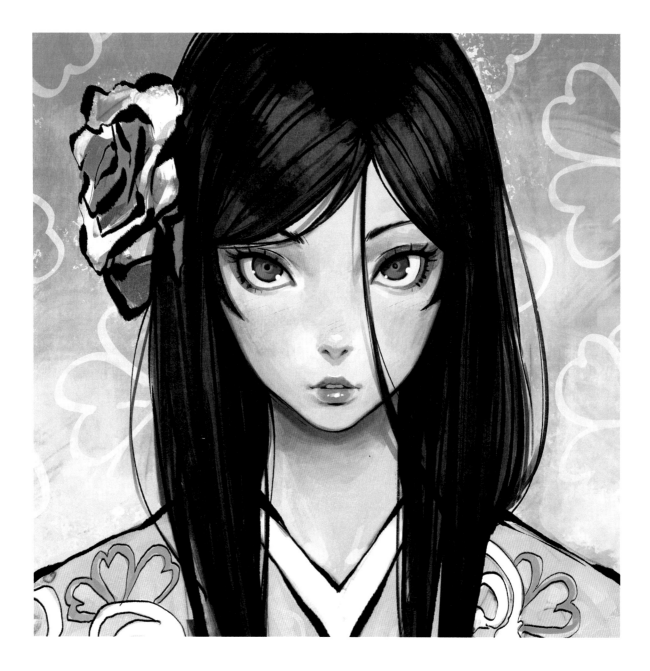

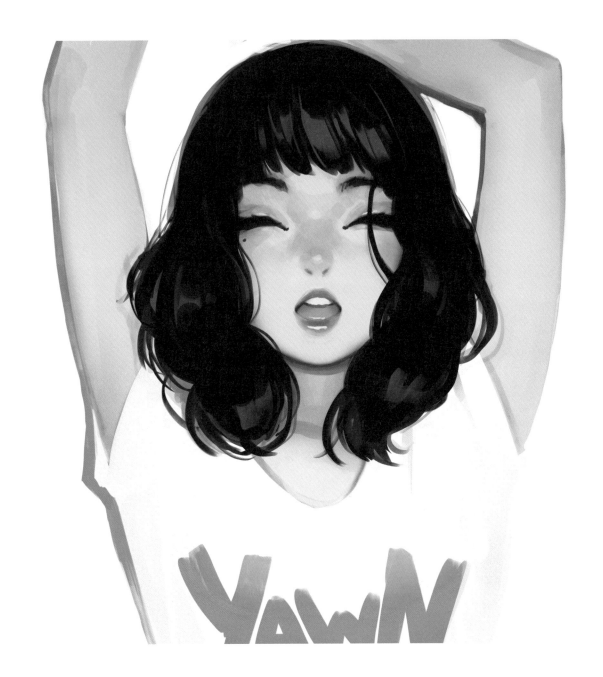

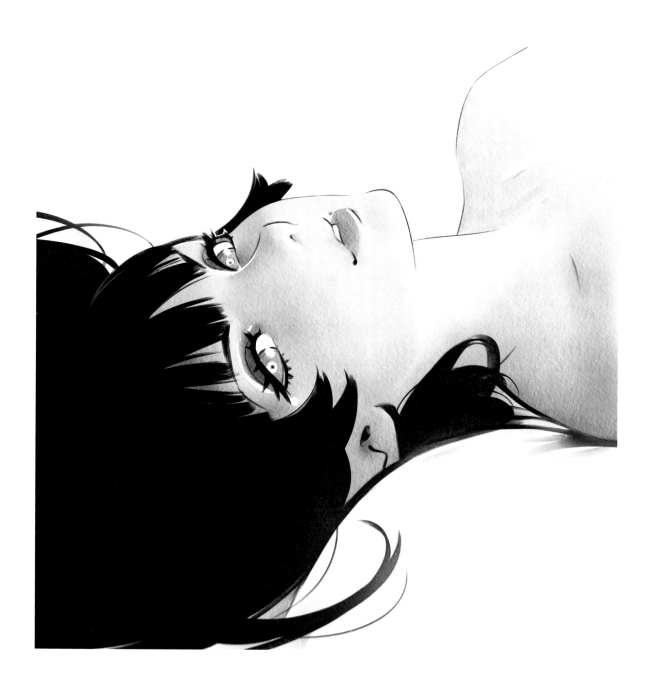

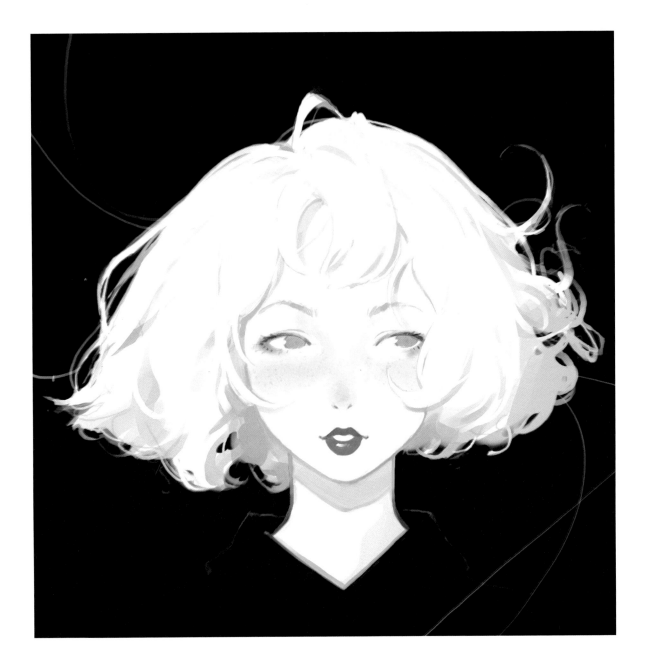

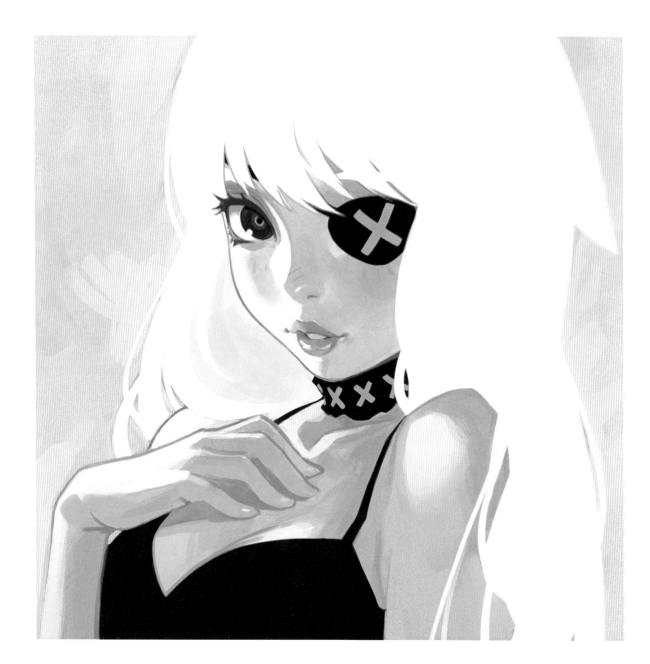

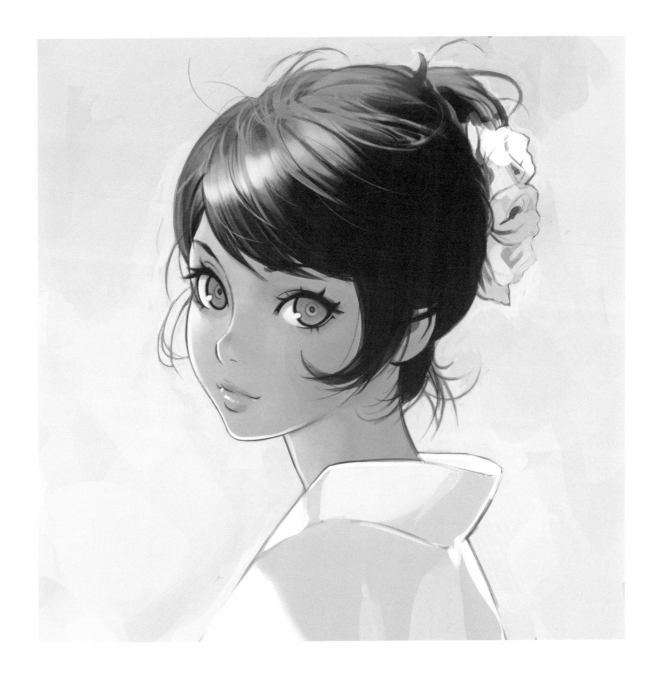

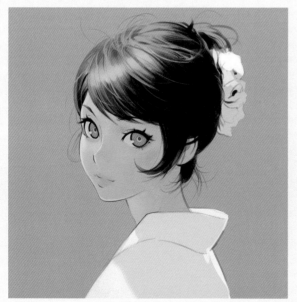
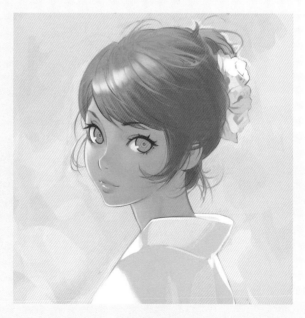

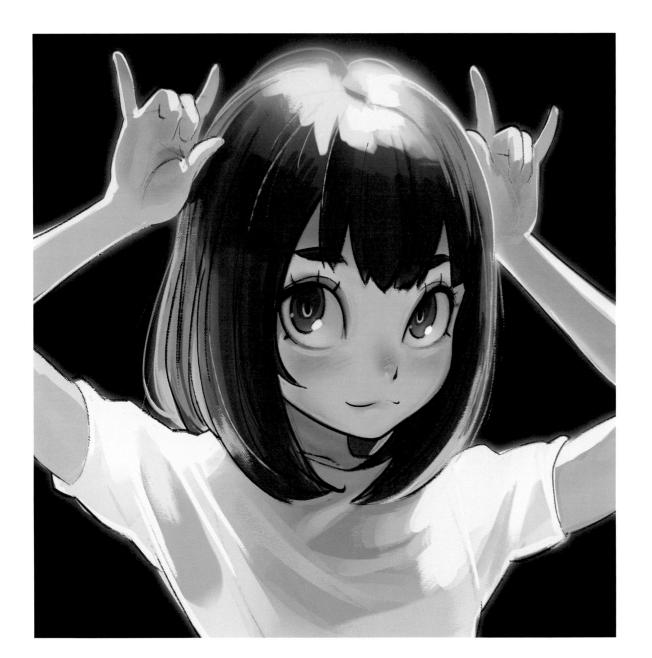

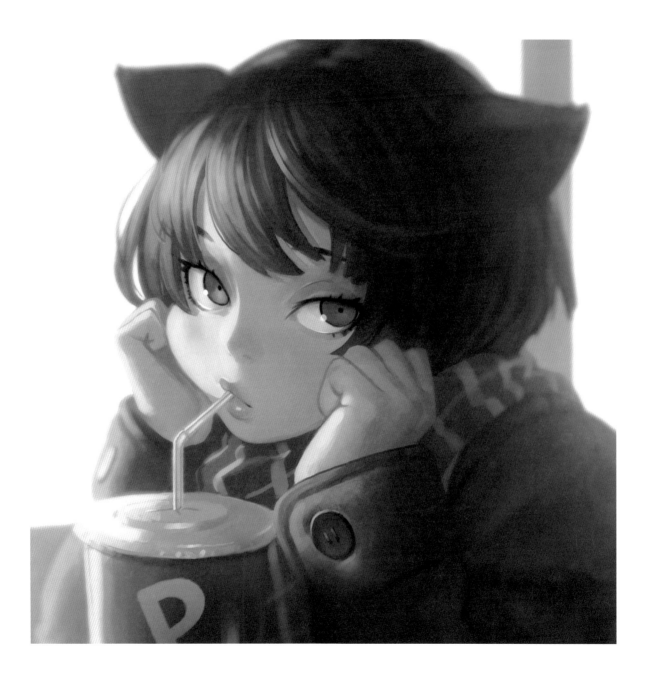

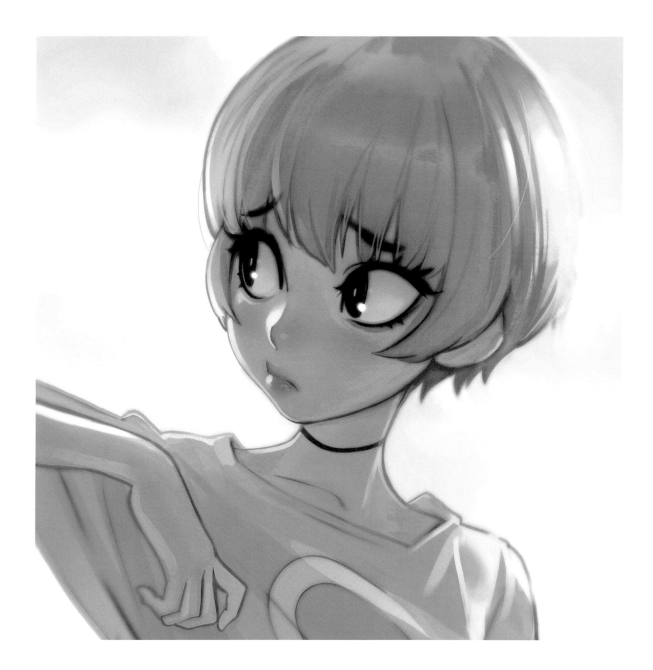

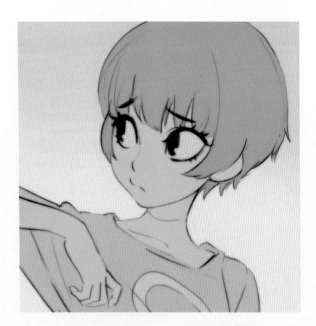
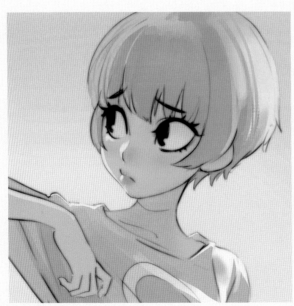
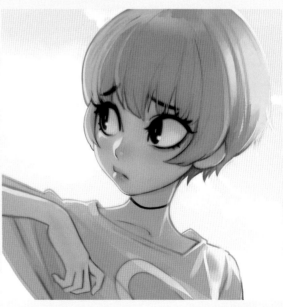

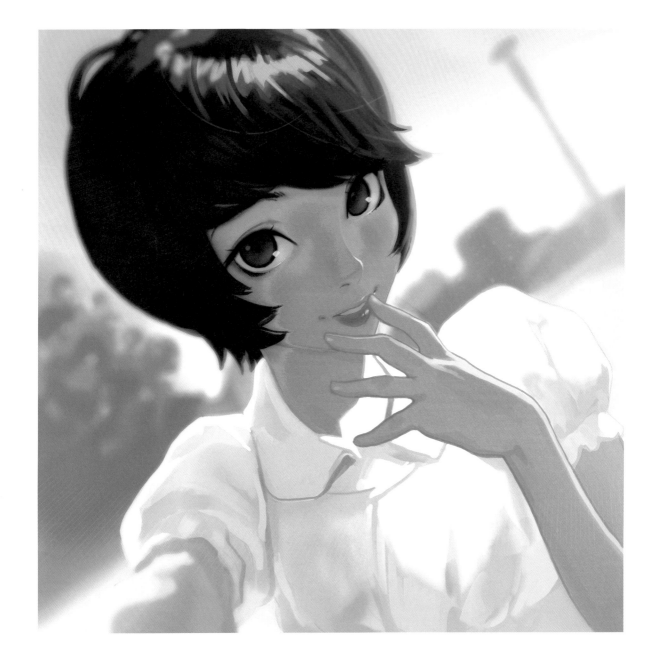

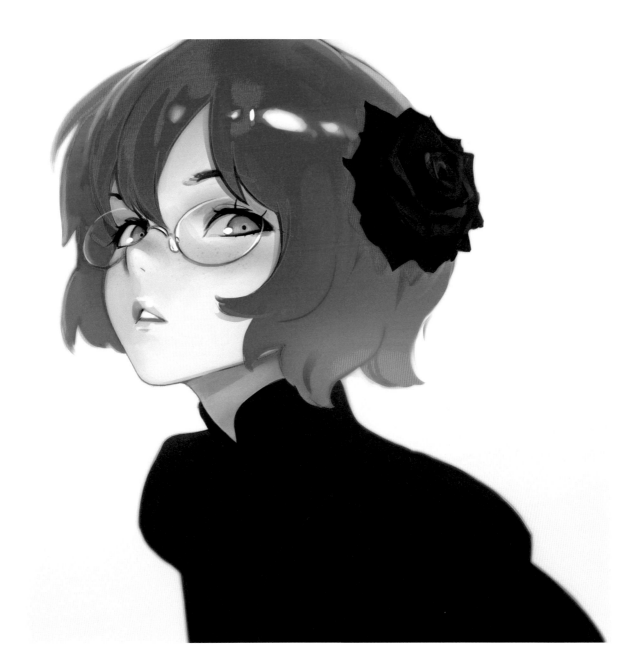

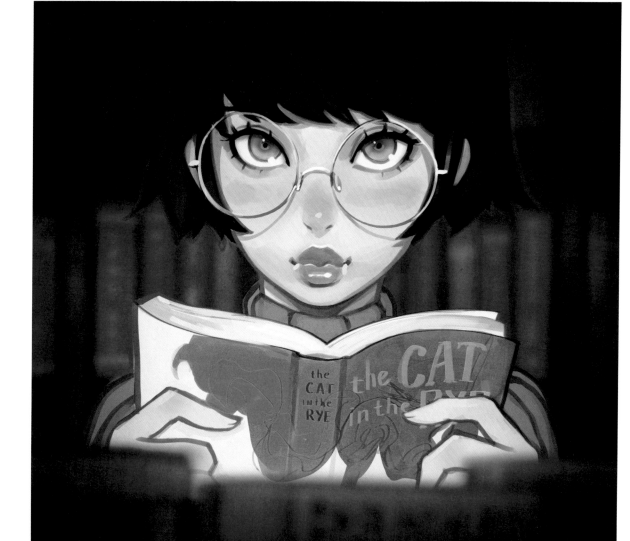

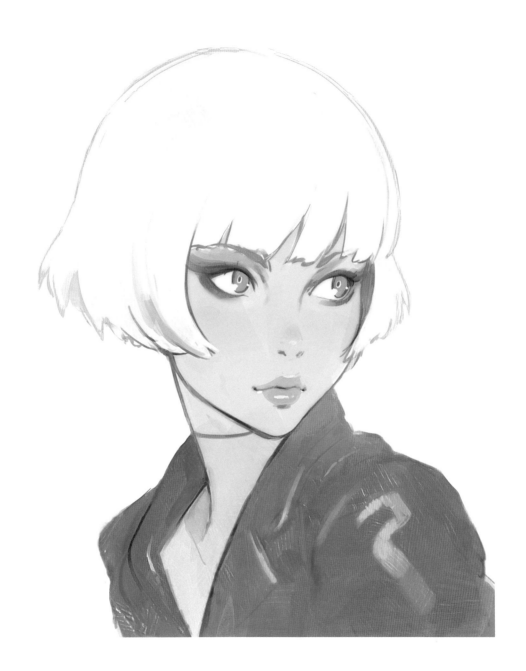

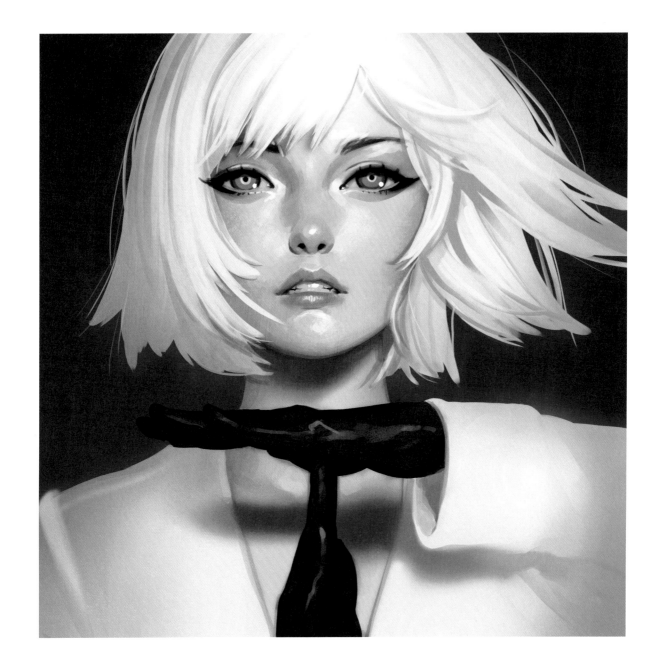

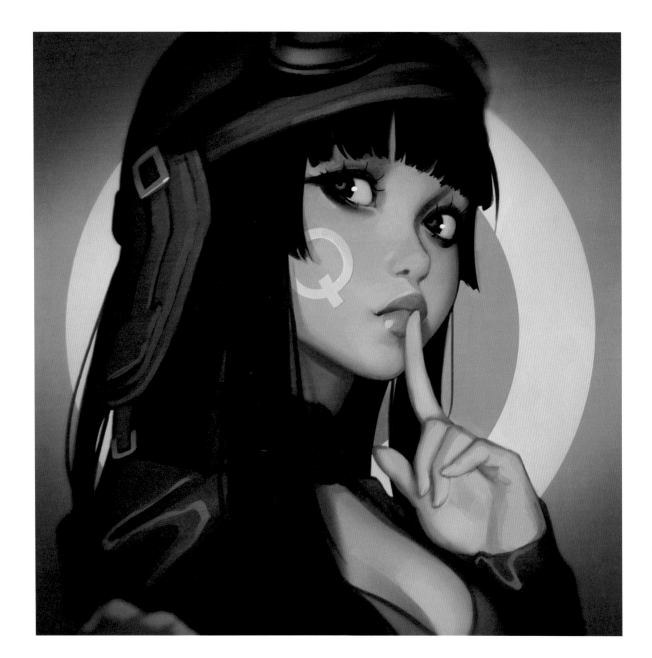

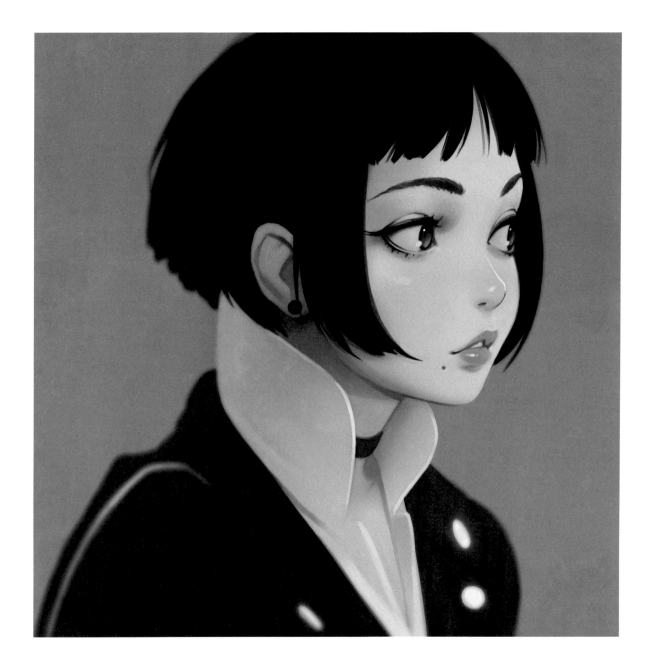

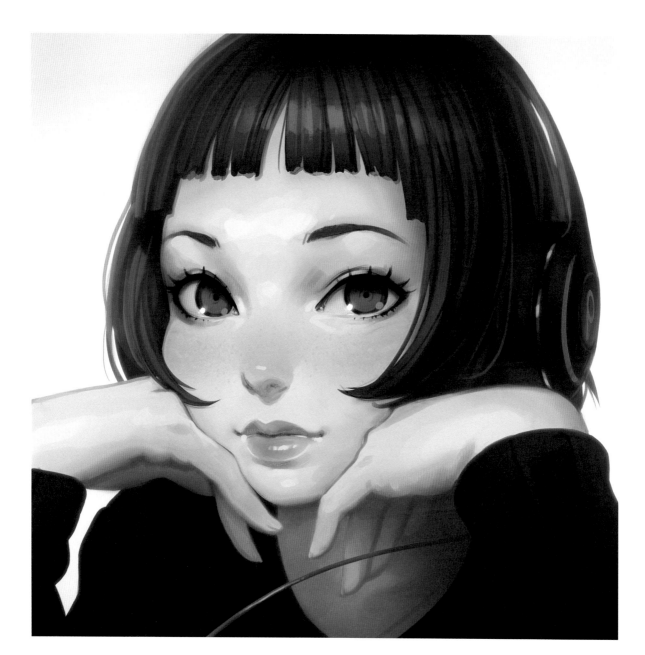

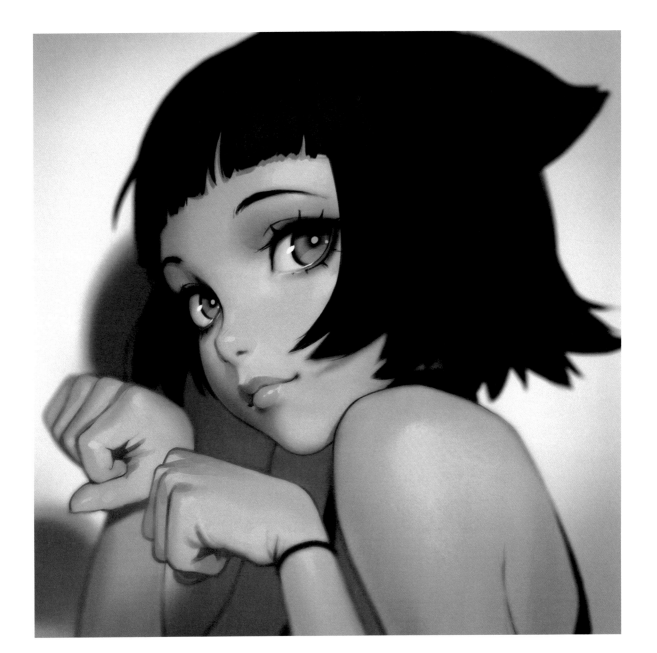

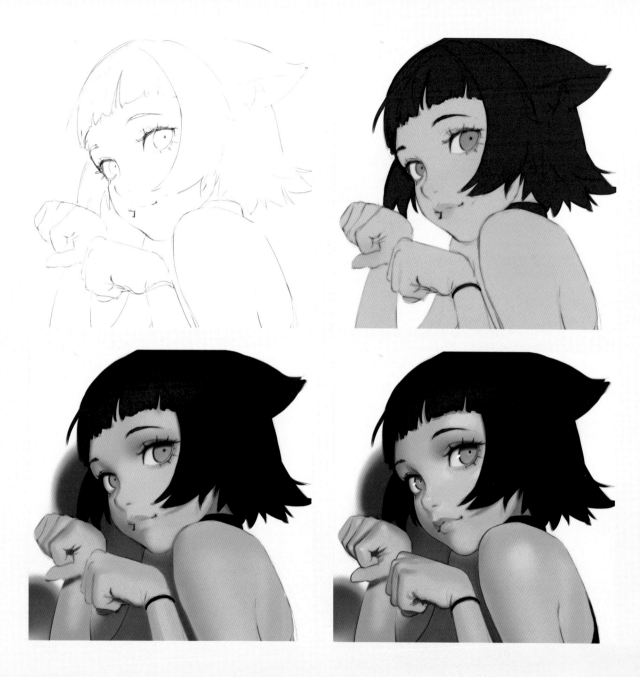

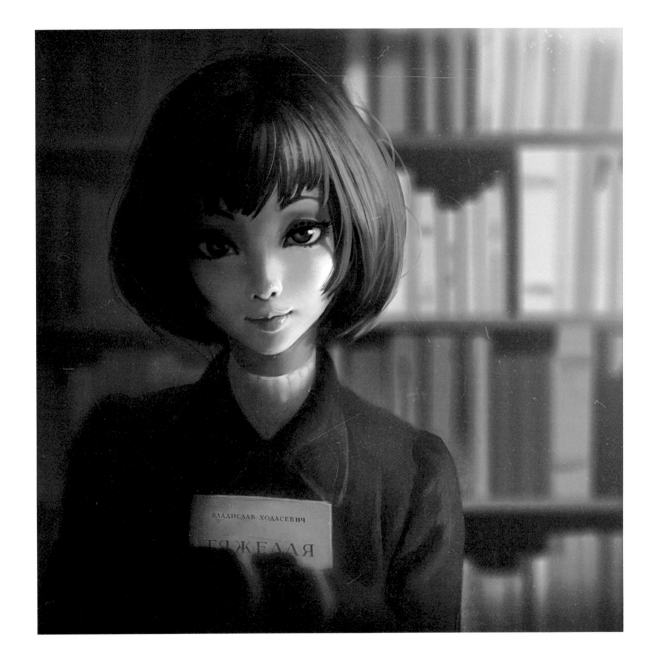

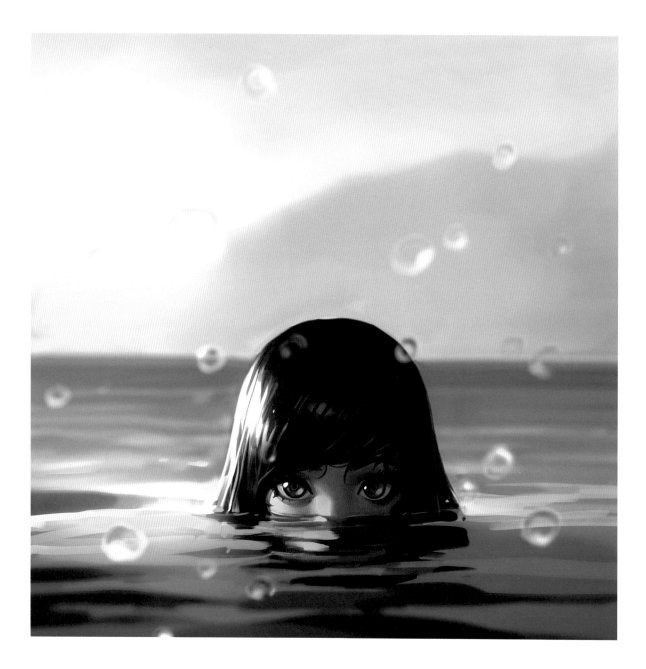

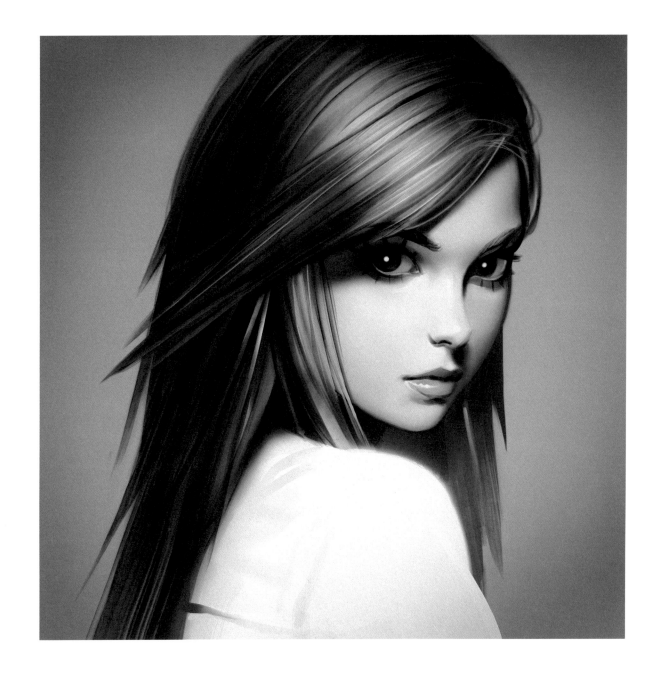

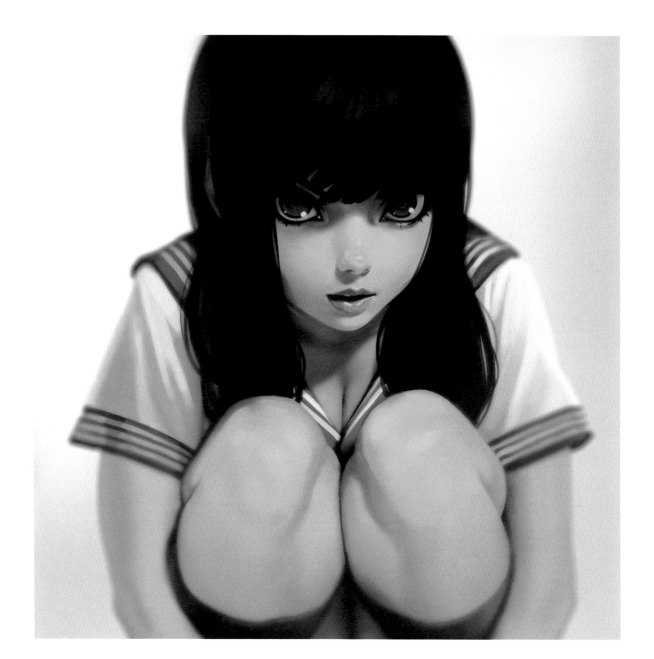

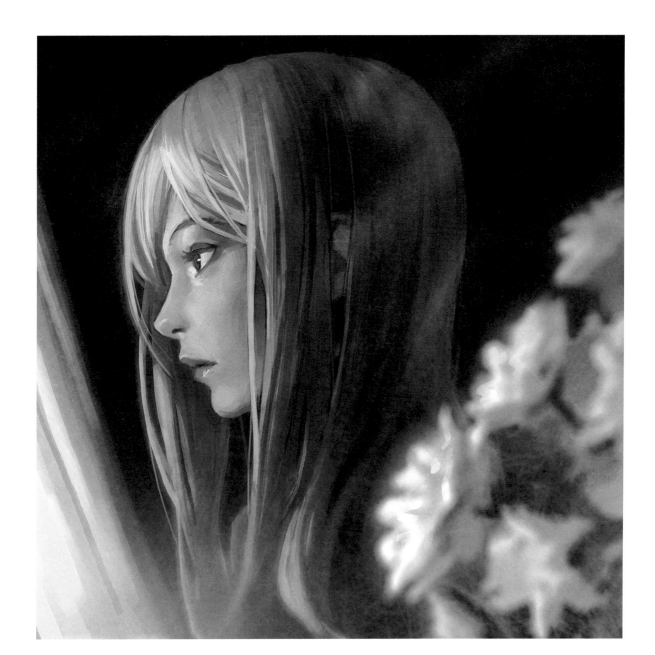

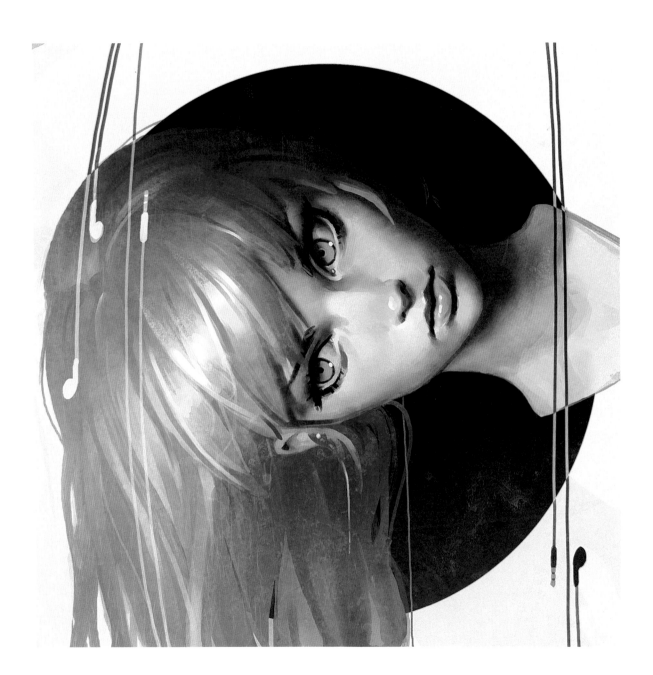

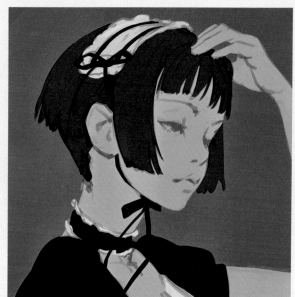
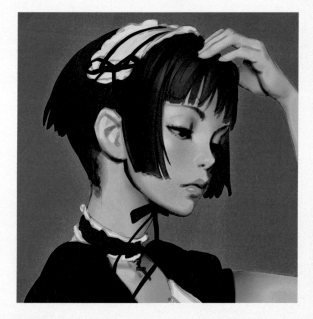
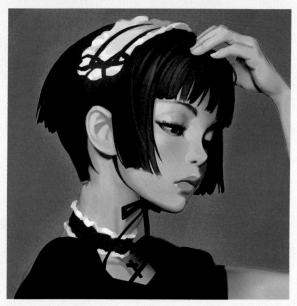

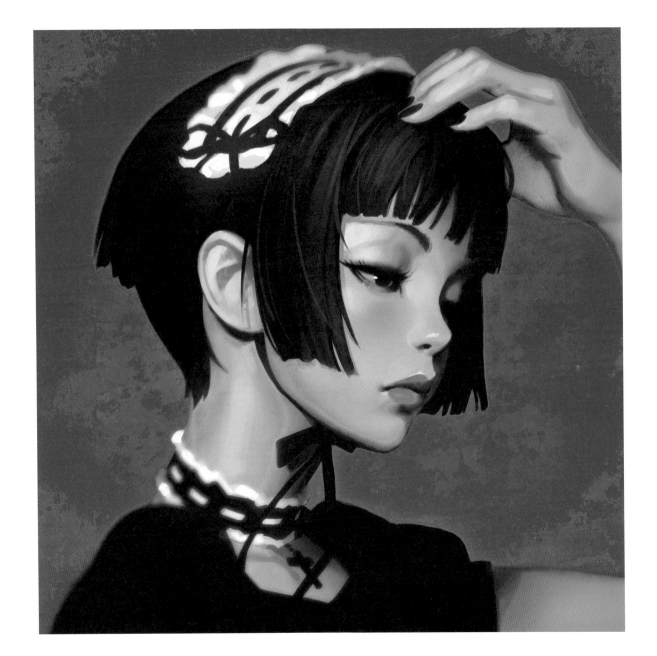

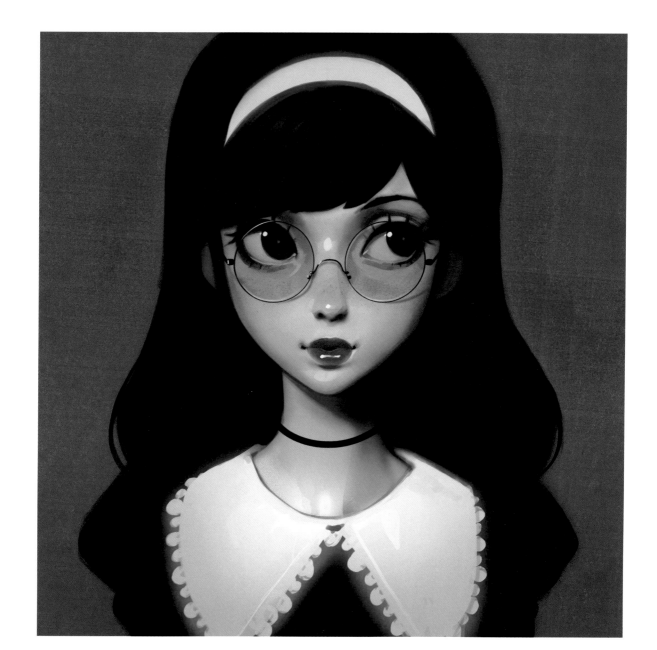

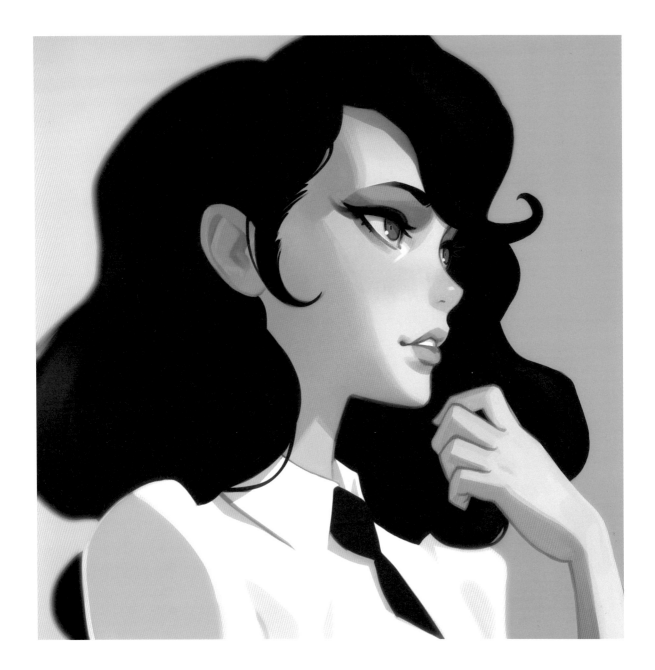

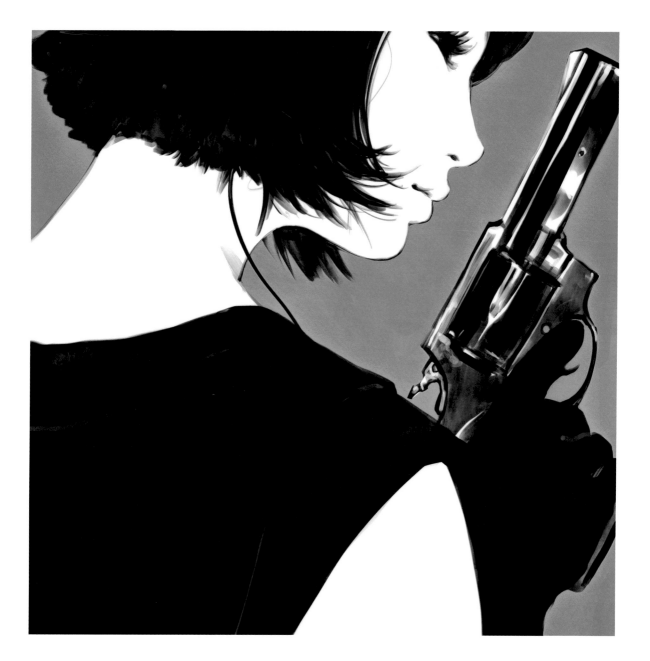

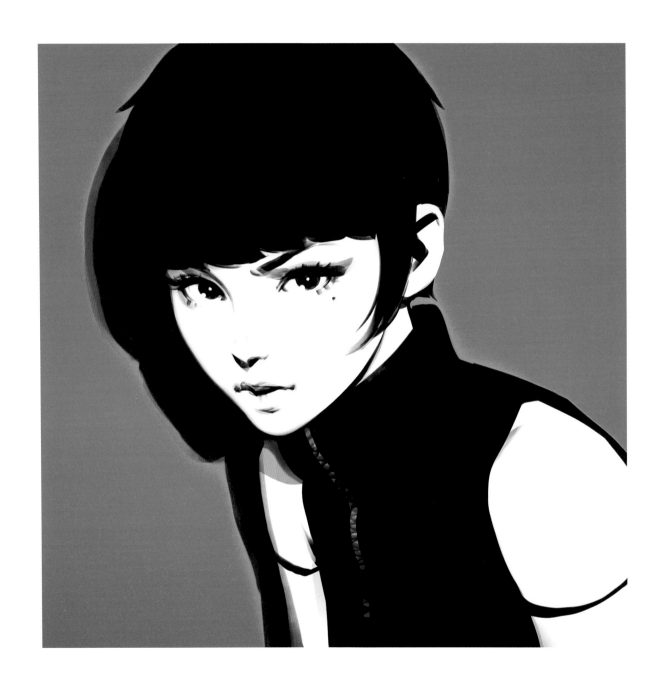

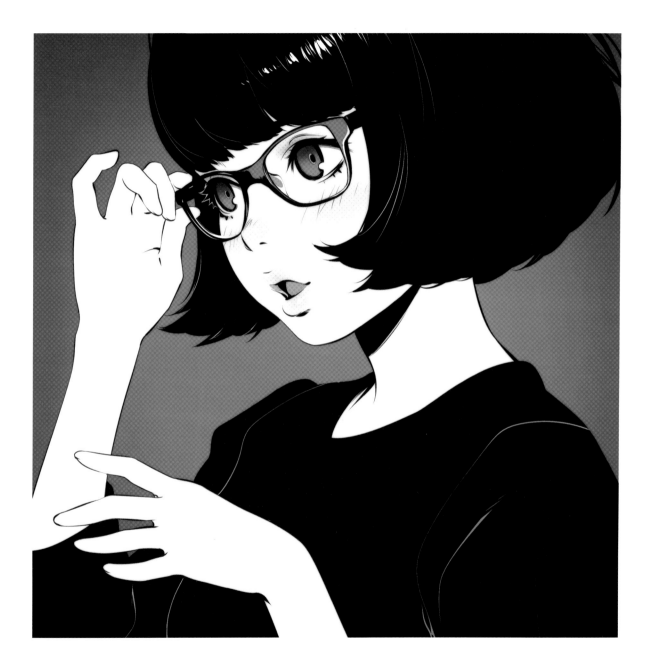

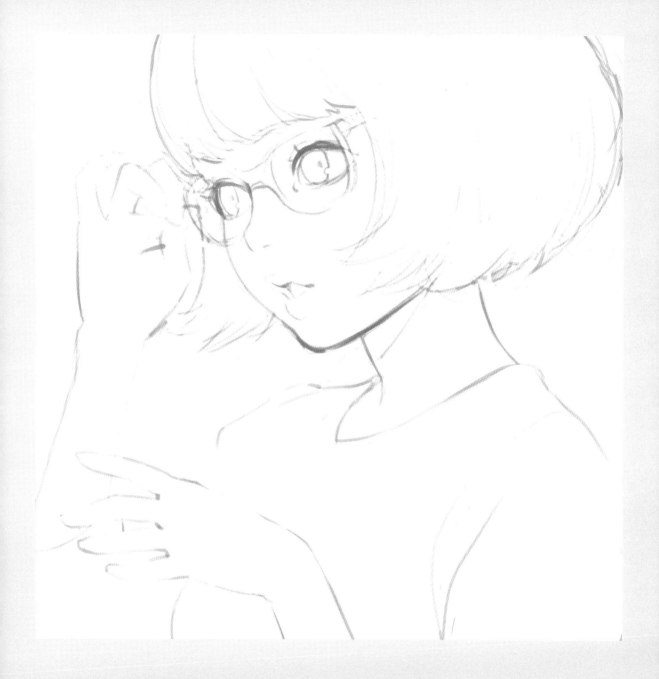

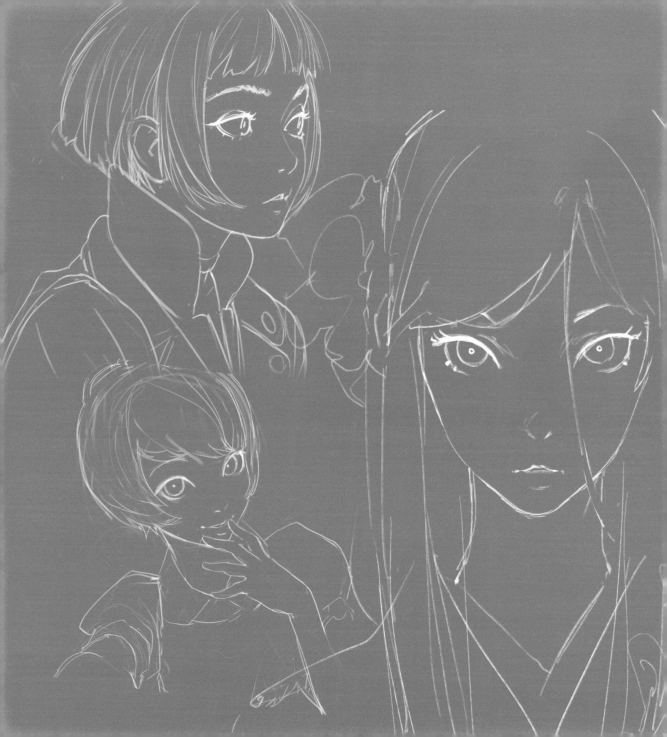

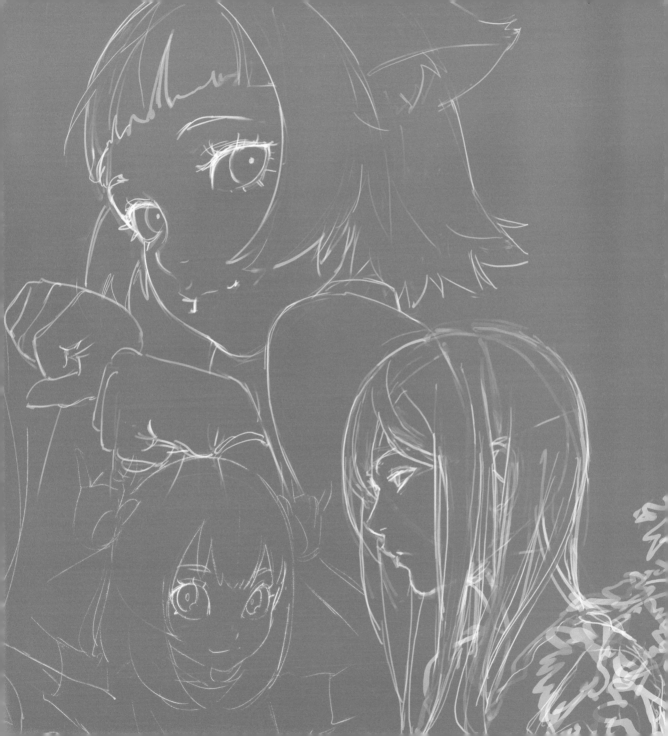

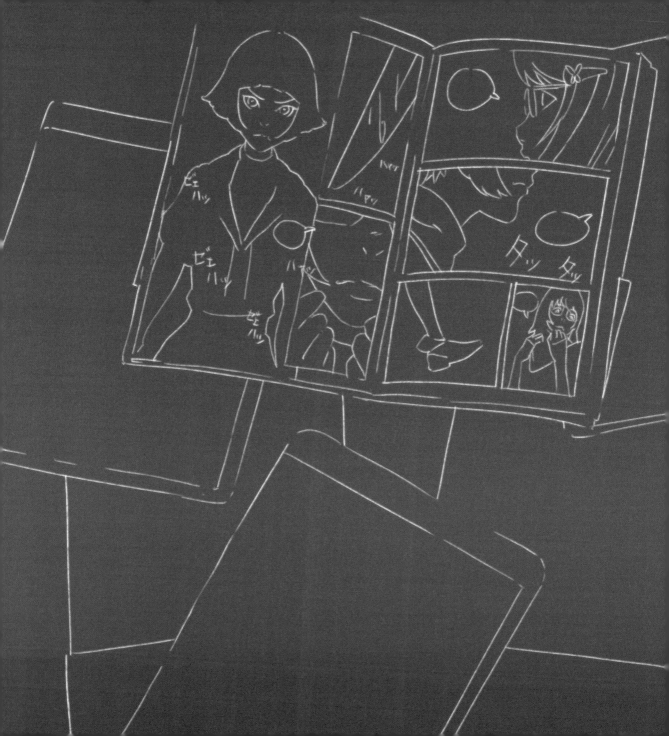

日本のアニメを初めて見たのは私が7歳のときでした。押井守監督の『GHOST IN THE SHELL / 攻殻機動隊』です。英語吹き替え版で内容をほとんど理解できなかったけれど、私の心に強く残りました。光学迷彩のシーンにはじまり、海へのダイブシーン、戦車との戦闘シーンなど、圧倒的なビジュアルの連続に目を奪われました。その当時はアニメや漫画のことも、『GHOST IN THE SHELL / 攻殻機動隊』が日本の作品だということも知りませんでした。ただ、このとき、自分もこれまでの常識を覆すような映画を作るという最終目標だけは心に決めました。

その頃のロシアには、ロシア語に翻訳された日本の作品はあまりなく、あったのは英語版ばかりでした。そこで私は英語に翻訳された、ストーリー性のある日本の作品を通して英語を勉強することにしたのです。そんな中、私は冬目景、高橋留美子、浅野いにお、あずまきよひこ、大友克洋、押井守、宮崎駿、今敏、細田守、庵野秀明などの大好きな作家に出会いました。彼らは皆スタイルこそ違いますが、ファンの心に響くストーリーや魅力的なキャラクターを作ることは共通しています。彼らの作品は私の心の奥深くに響き、私を突き動かす原動力となっています。

I first experienced Japanese anime when I was seven years old. "GHOST IN THE SHELL", directed by Mamoru Oshii deeply impressed me despite me barely understanding its English dub. Even so, I was captivated by the film's visual sequences such as the opening optical camouflage scene, the diving scene in the ocean and the tank battle scene. At the time, I knew nothing about anime or manga and was unaware that it was a Japanese film. But this is what made me realize my ultimate goal: to create a visionary film like this.

Japanese media was rarely translated into Russian, but instead was dubbed or translated into English. I took it upon myself to learn English bit by bit through Japanese story-oriented content. And I discovered my favorites: Kei Toume, Rumiko Takahashi, Inio Asano, Kiyohiko Azuma, Katsuhiro Otomo, Mamoru Oshii, Hayao Miyazaki, Satoshi Kon, Mamoru Hosoda and Hideaki Anno. Though they all differ in style, all their stories star characters that deeply touch their audiences. These creations resonate deeply with me and have become my passion in life.

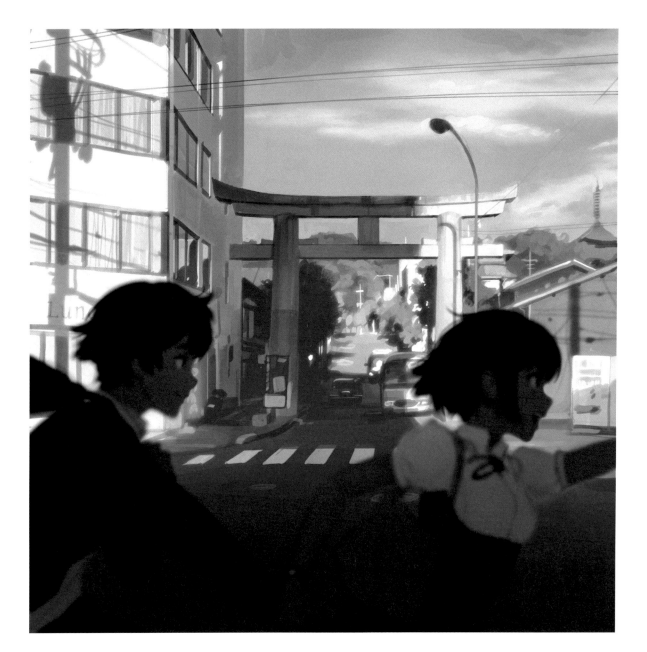

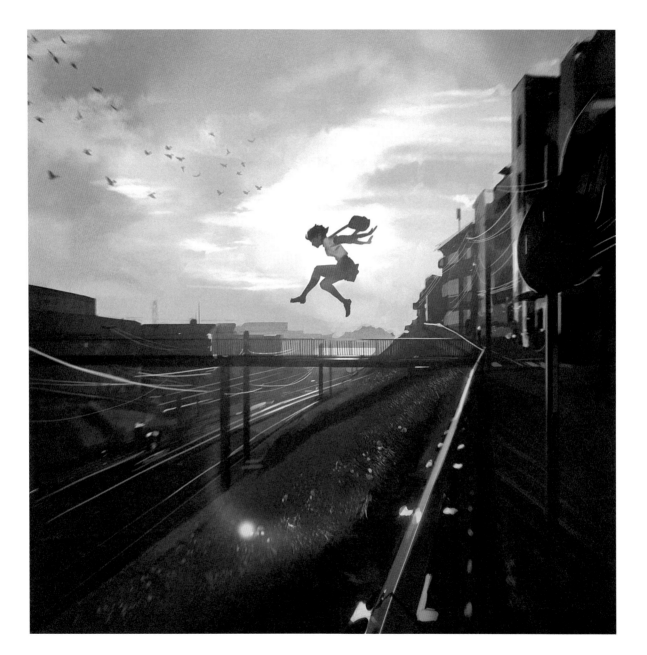

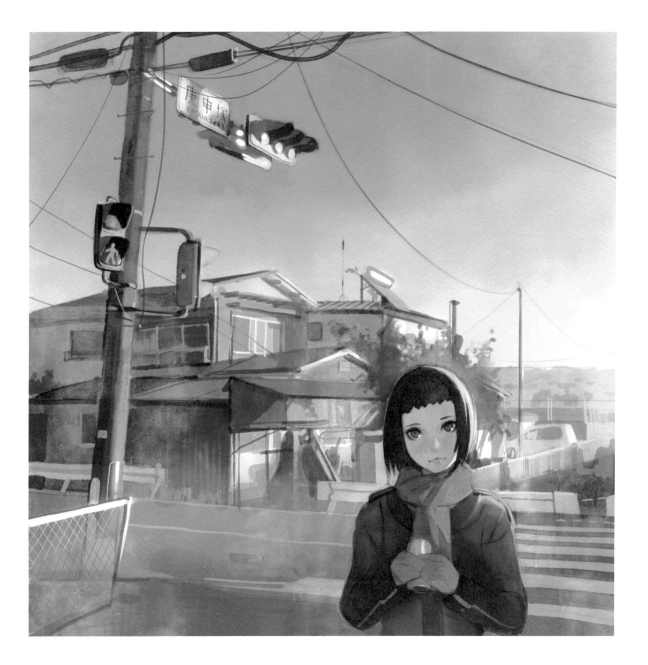

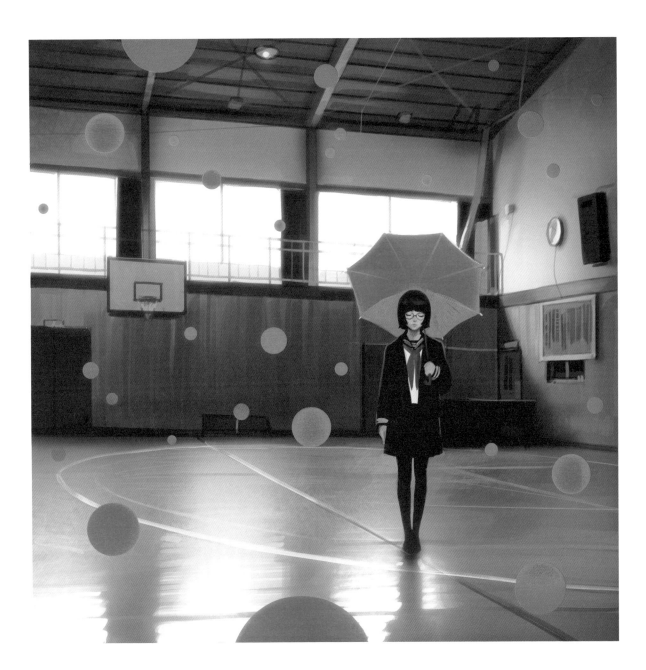

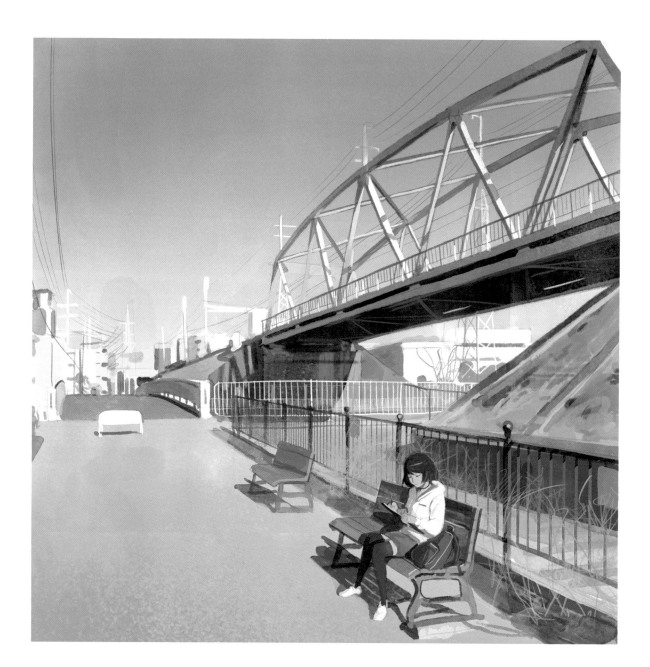

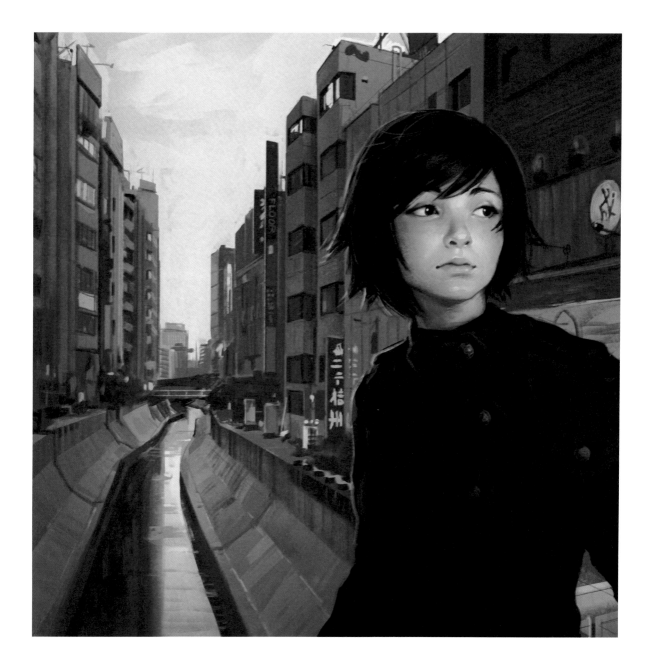

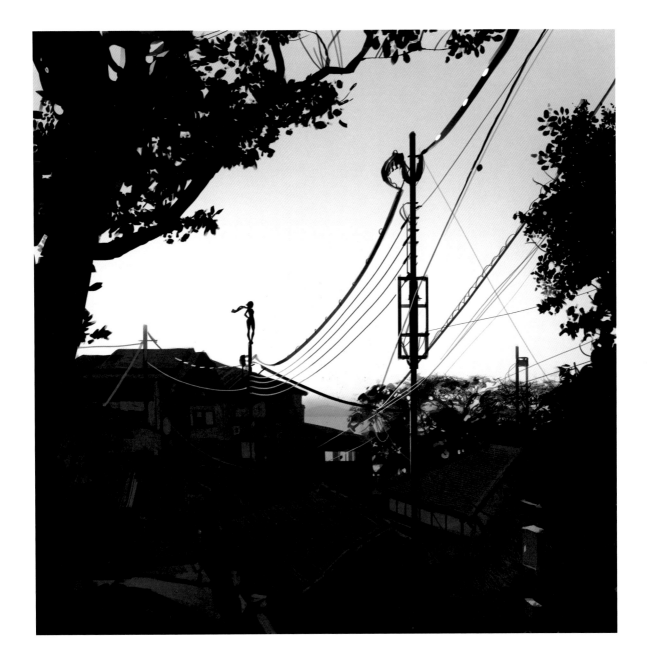

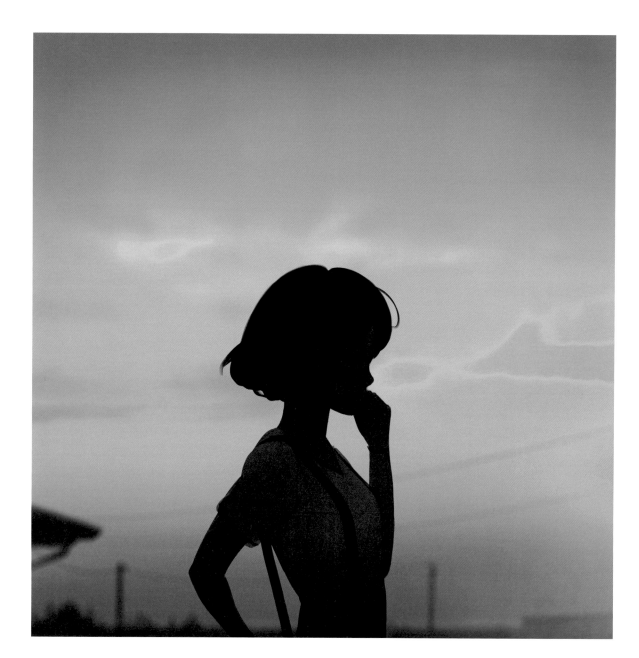

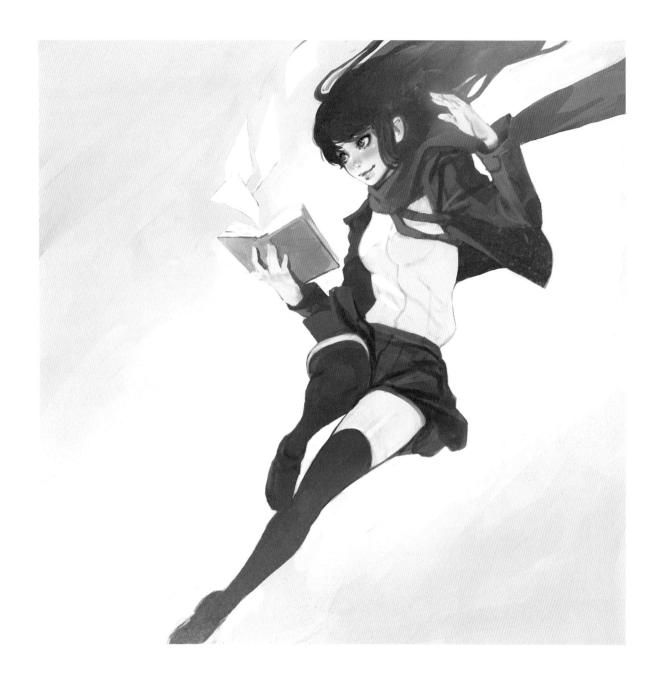

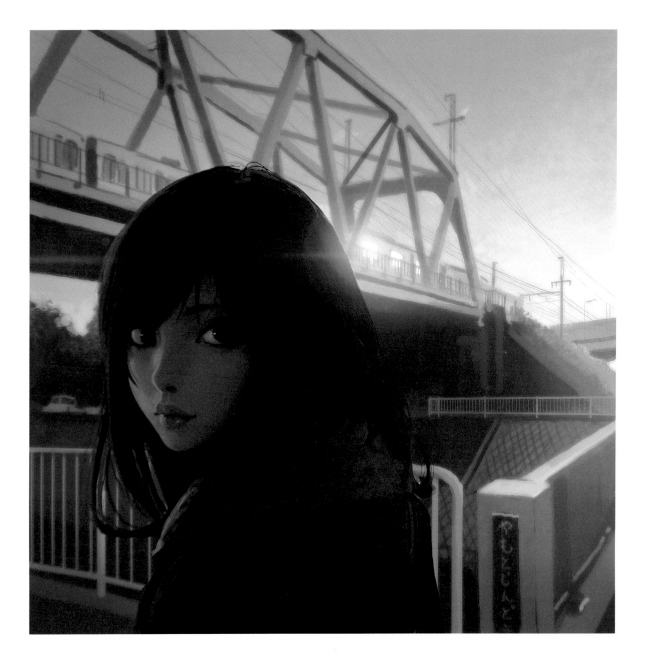

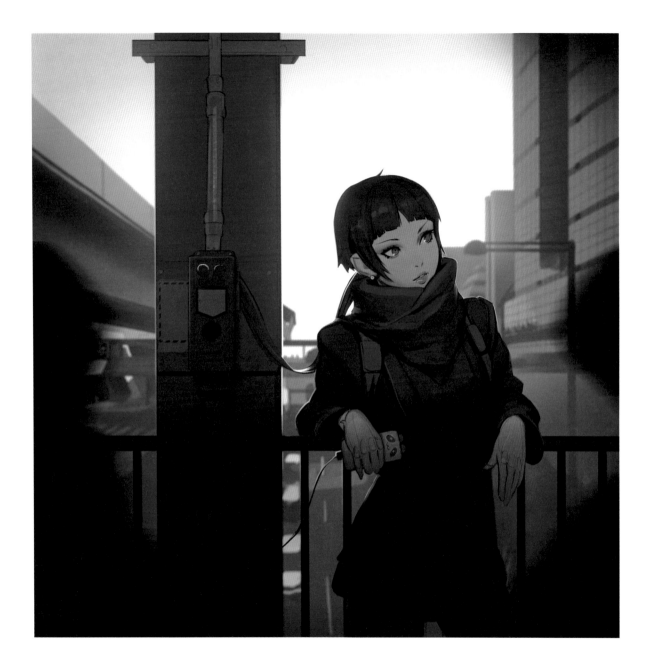

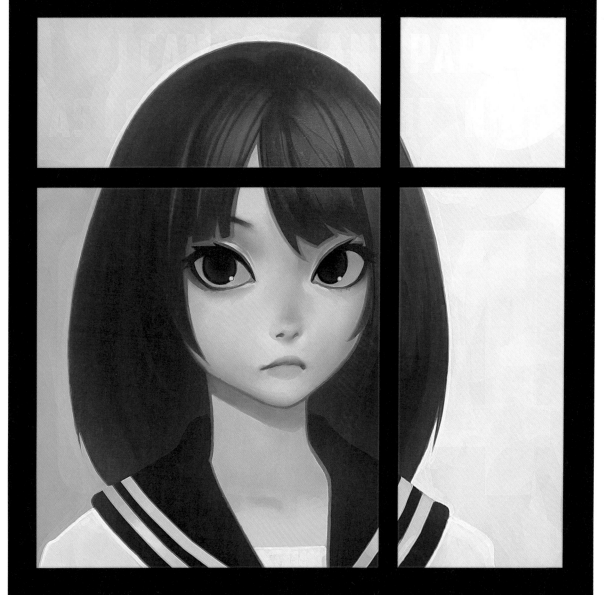

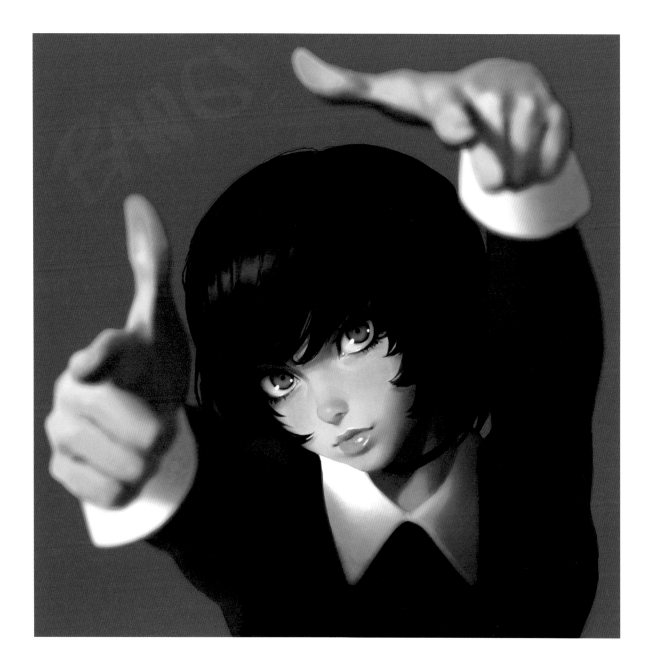

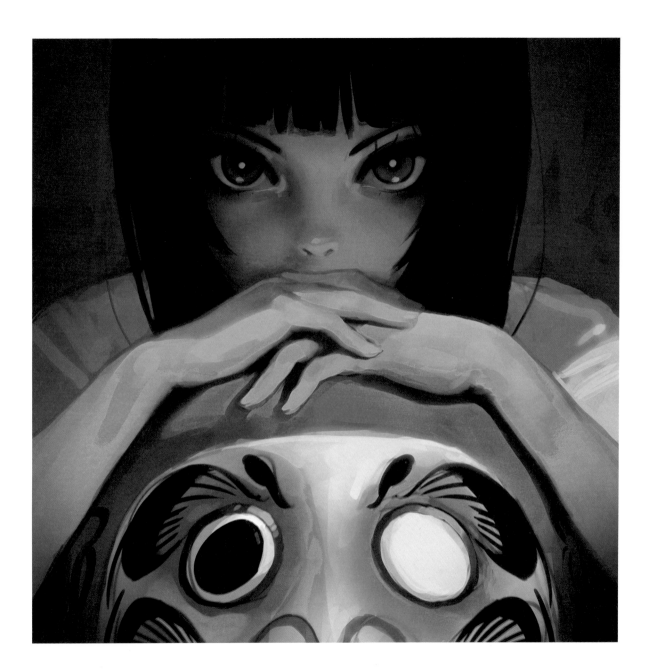

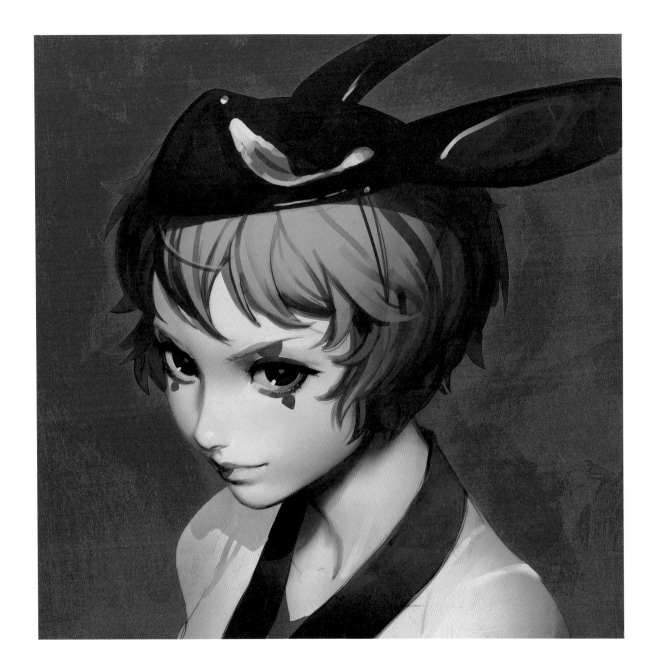

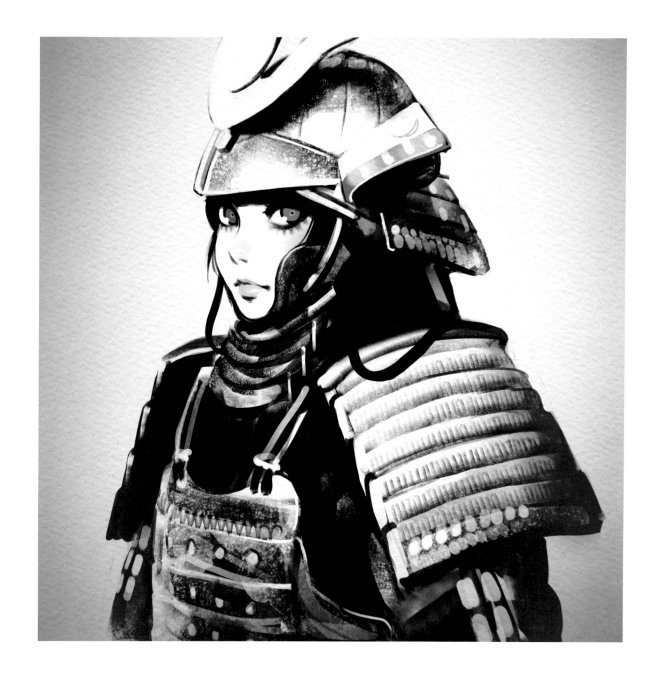

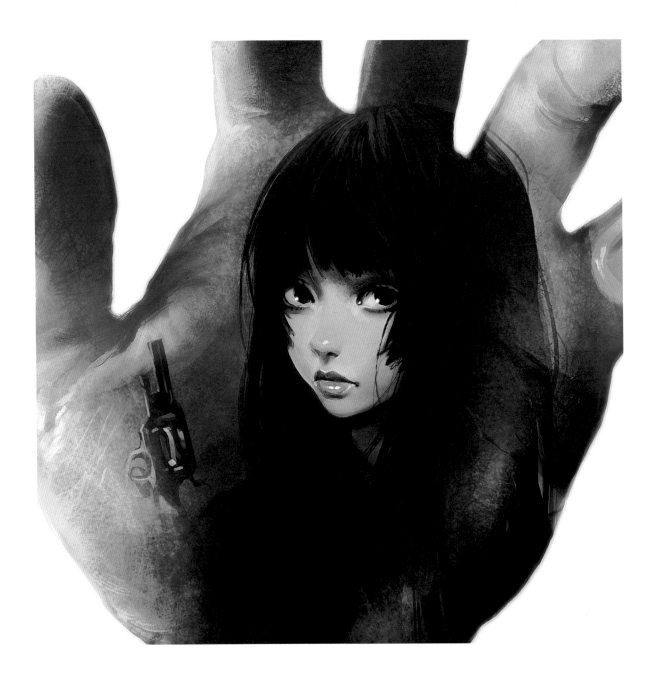

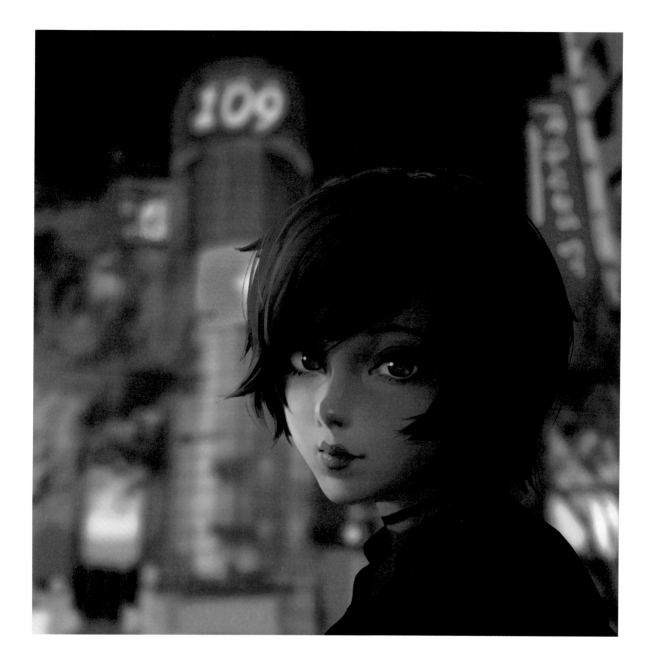

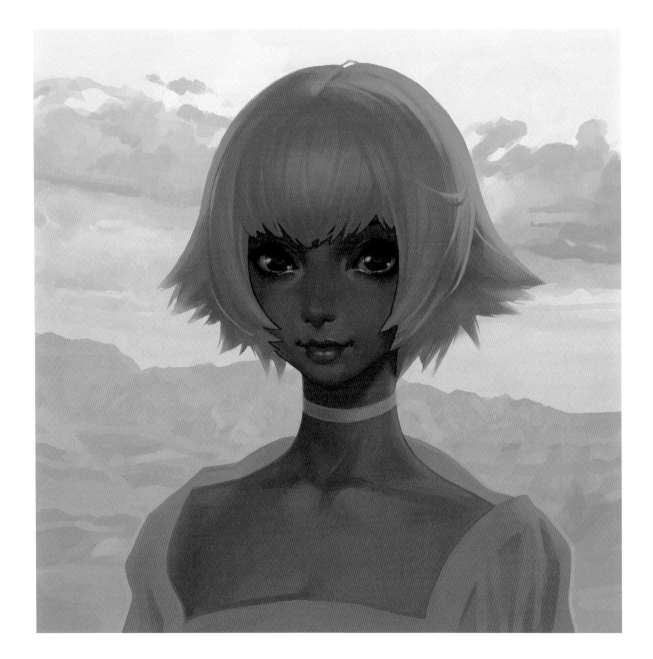

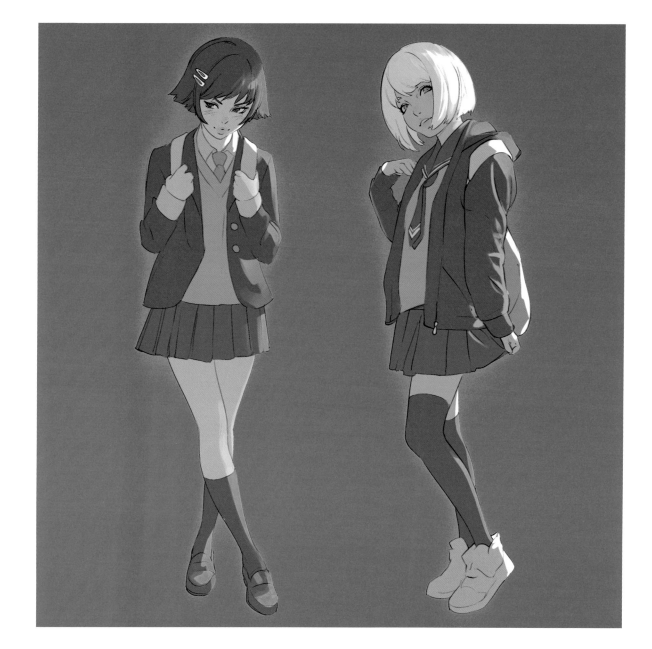

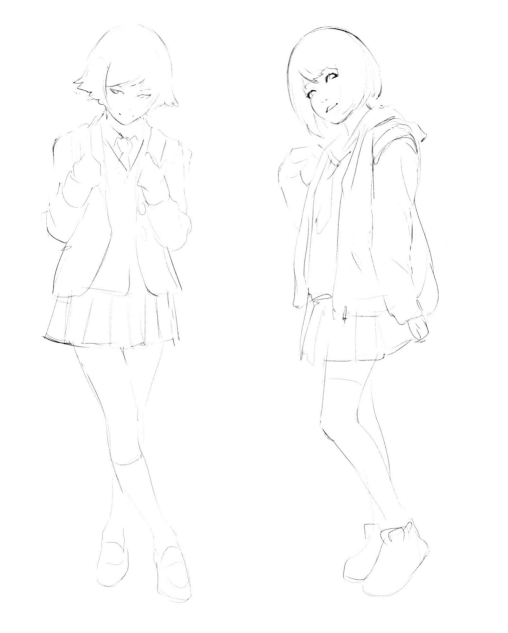

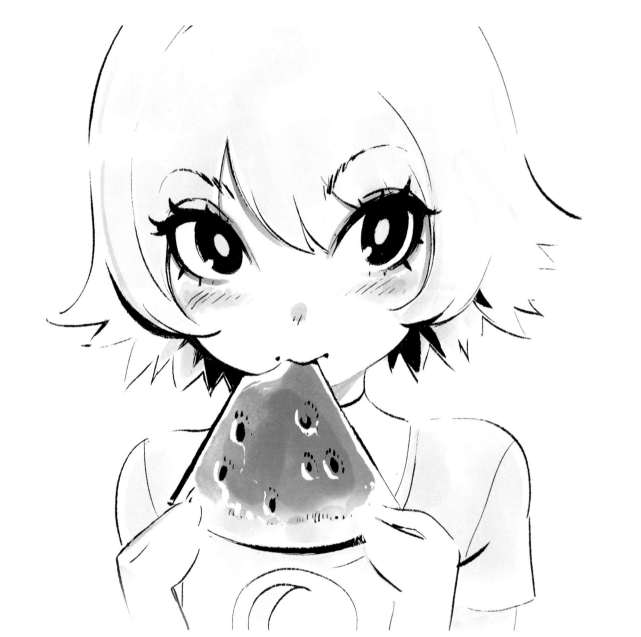

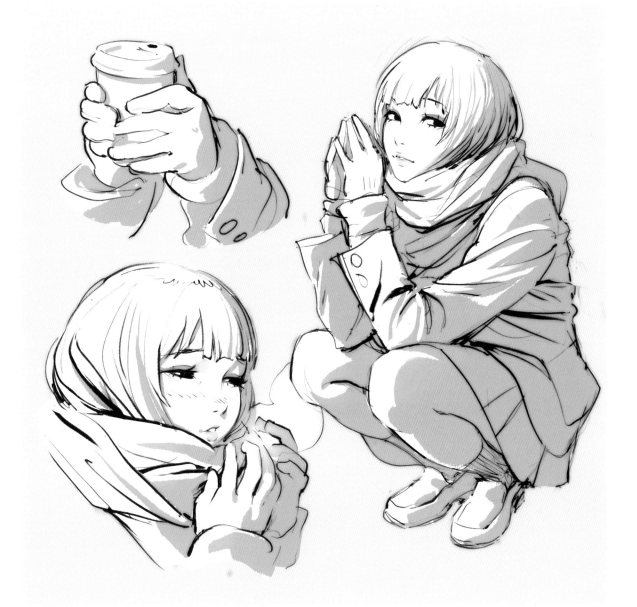

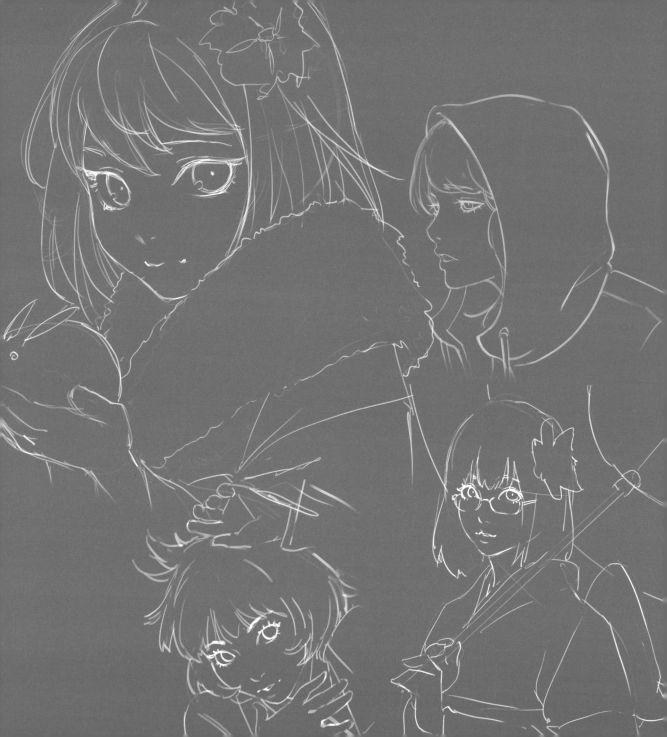

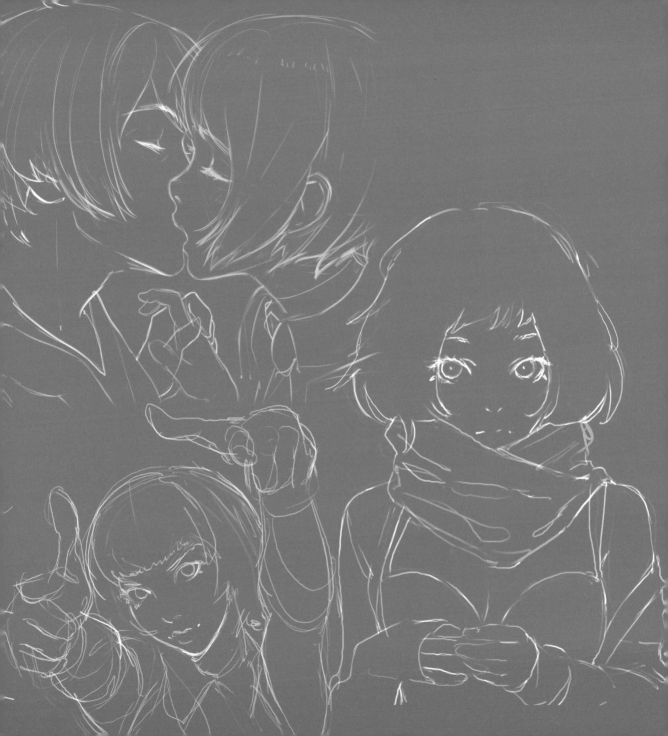

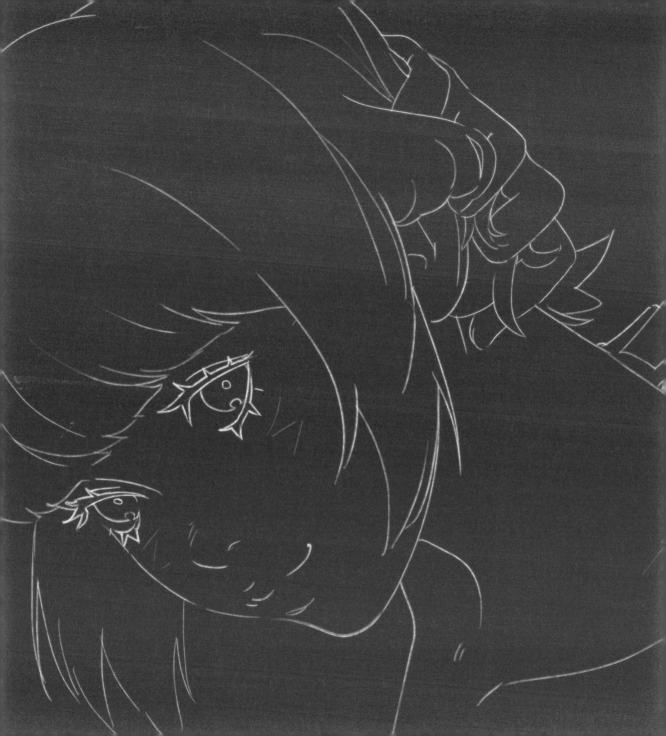

私のイラストに未来的なテイストが多いのは、モスクワでSF作品の制作に携わっていたことが深く影響していると思います。2012年、私はモーションコミックのスペースオペラ作品、"Knights of the Void"のコンセプトアーティストをしていました。作品のテーマを理解するために、映画や小説やアニメなどたくさんのSF作品を鑑賞し、その世界観に没頭しました。さらに、自分の手でエイリアンや武器や宇宙船などをデザインすることで、徐々にSF作品への理解を深めていったのです。

程なくして私はこの作品のシリーズディレクターに就任し、絵コンテや各セクションの制作管理など、シリーズ全体を任されるようになりました。それまで絵コンテを描いたことがなかったので、はじめはひどい出来でした。また、大勢のスタッフをマネージメントするのも初めての経験でした。でも、私は新しい環境に喜びを感じていました。チャレンジとして始まった仕事にいつしか夢中になり、この経験が私の人生のターニングポイントとなったのです。

I've drawn a large amount of futuristic illustrations, largely influenced by the sci-fi projects I worked on in Moscow. Back in 2012, I worked as a concept artist on a motion-comic space opera called "Knights of the Void". I immersed myself in SF movies, books, anime and electronic music in order to better understand these themes. Through designing aliens, guns and spaceships, I grew accustomed to Sci-Fi.

Shortly after, I was promoted to series director, expanding my responsibilities to storyboards, managing each stage of production, etc. My early storyboards were terrible because I lacked previous experience. Overseeing a large number of staff was new to me but I loved my new set of responsibilities. What began as a challenge became my passion and a turning point of my life.

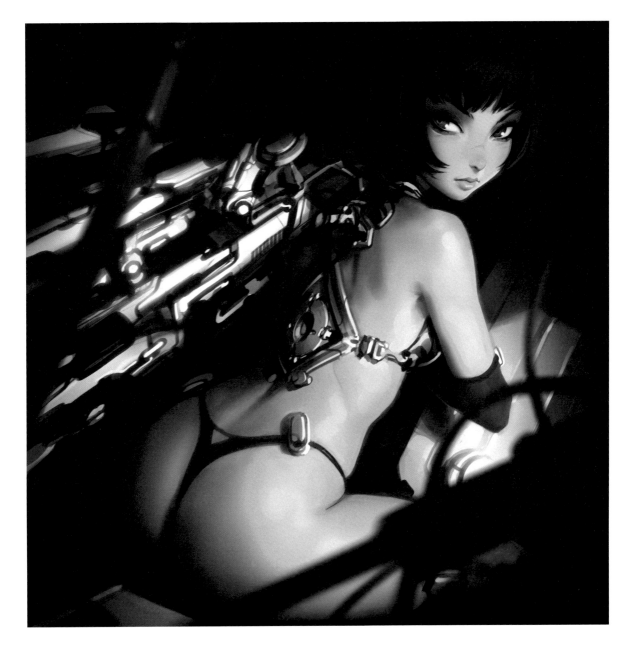

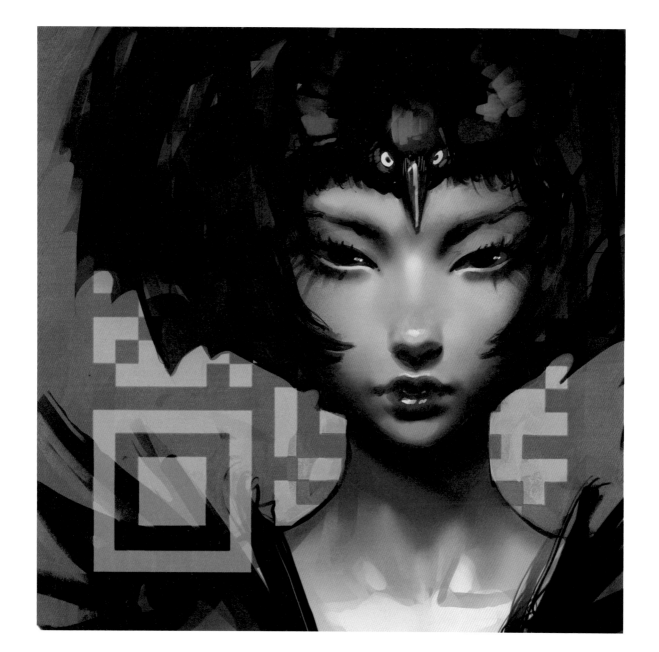

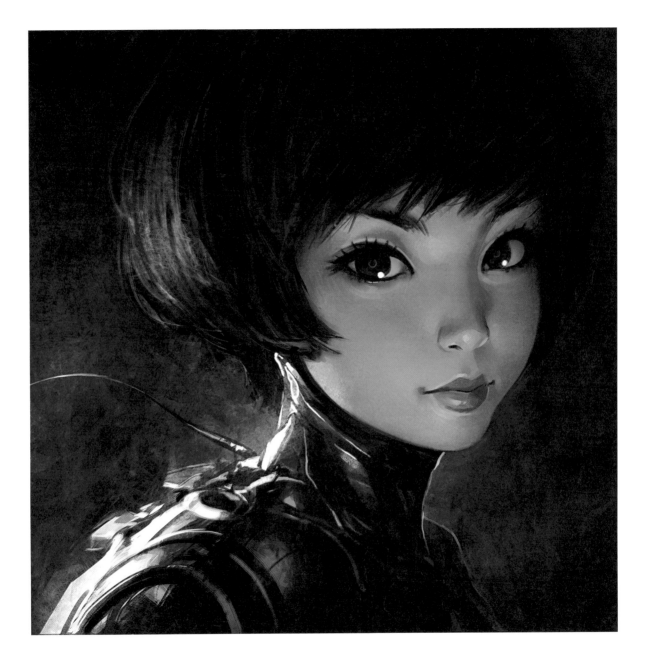

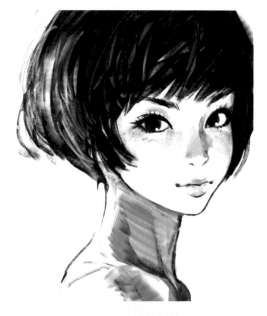
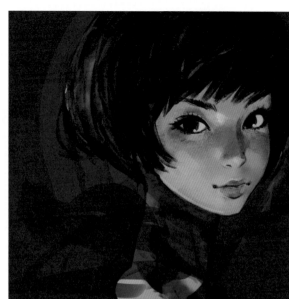
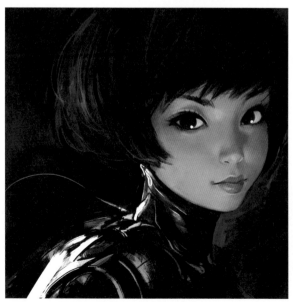
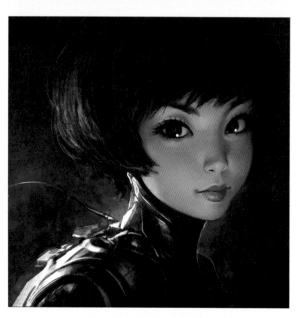

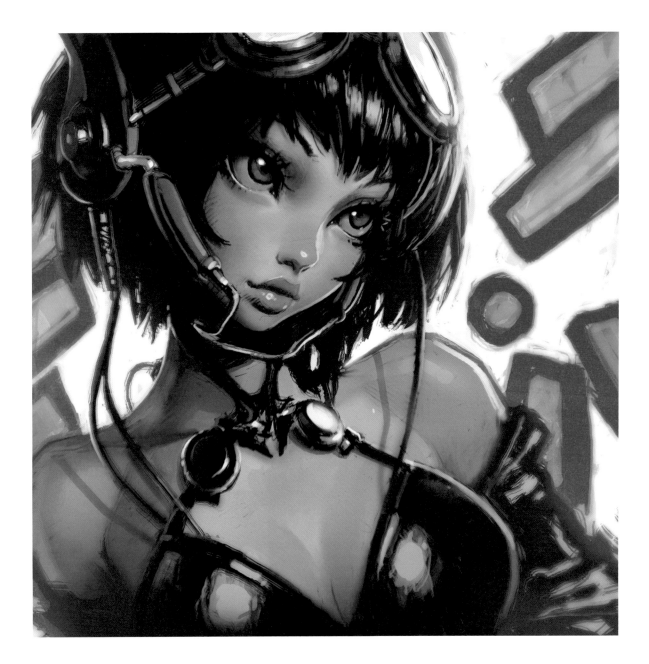

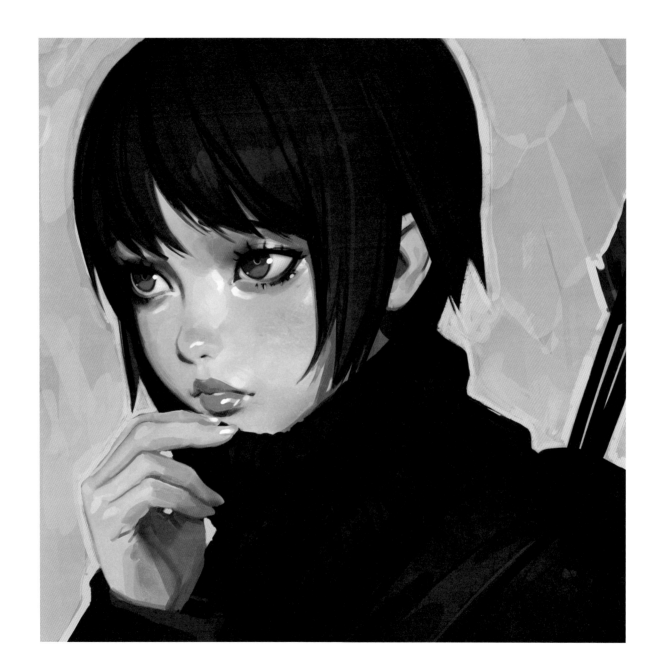

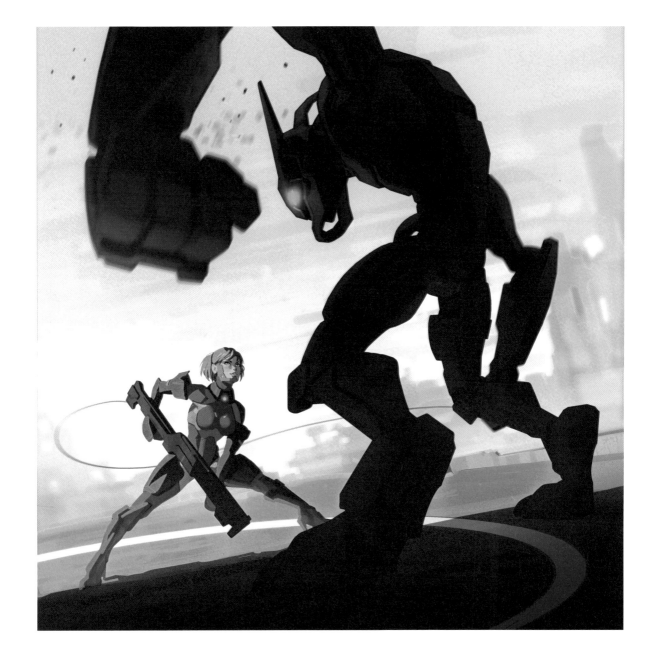

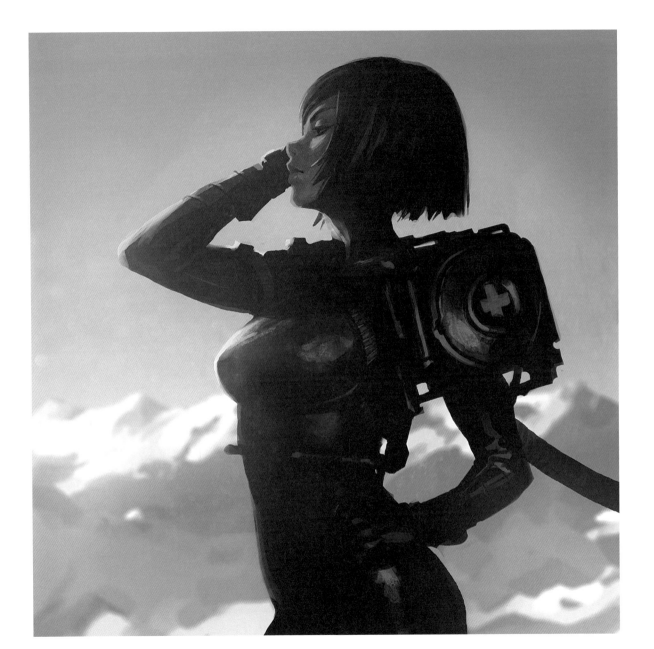

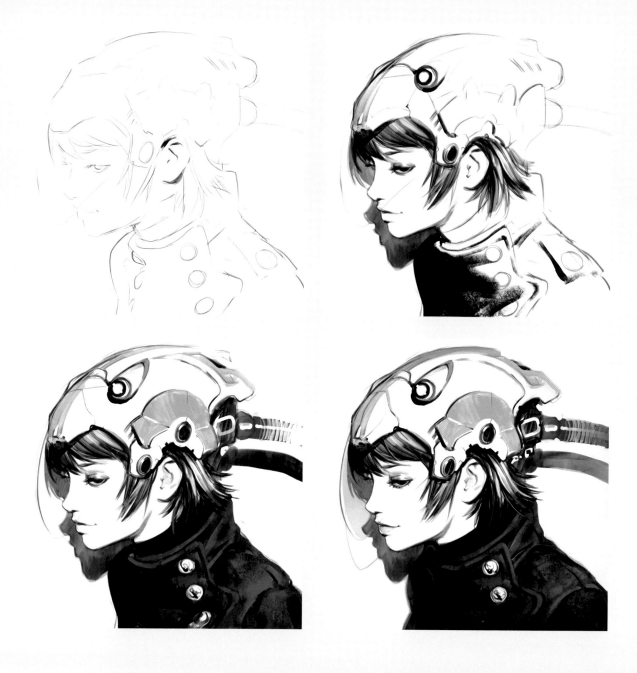

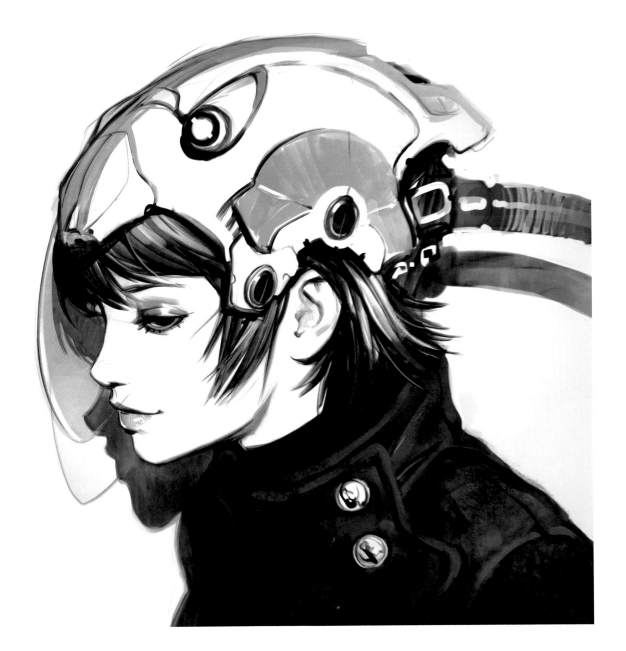

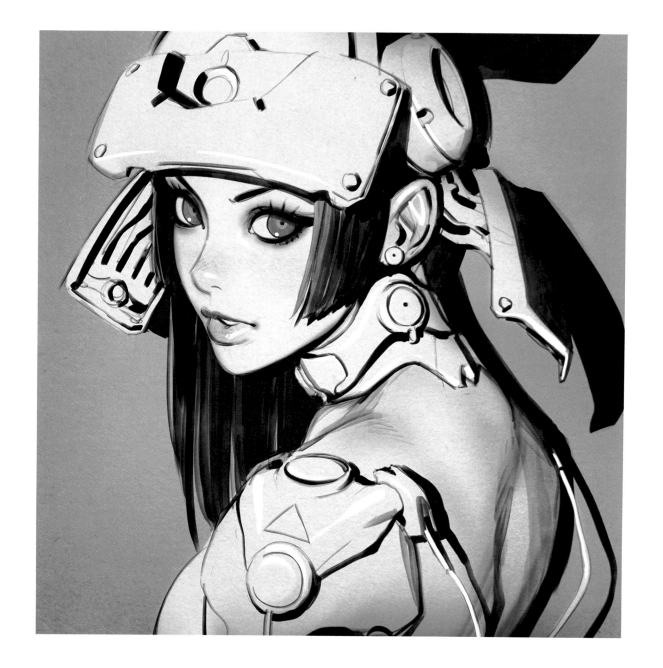

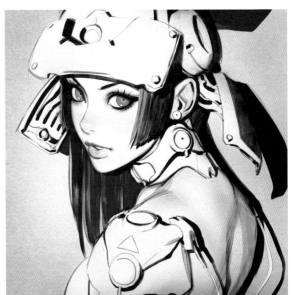
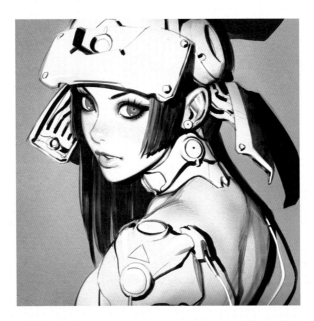

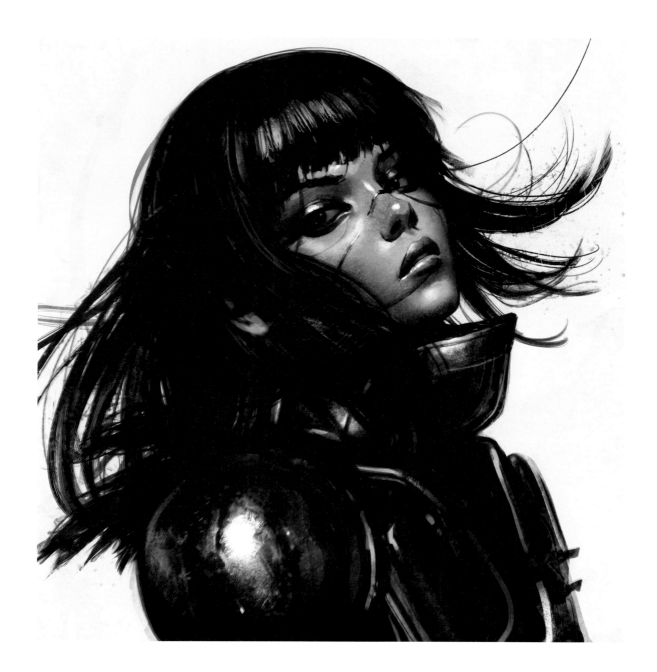

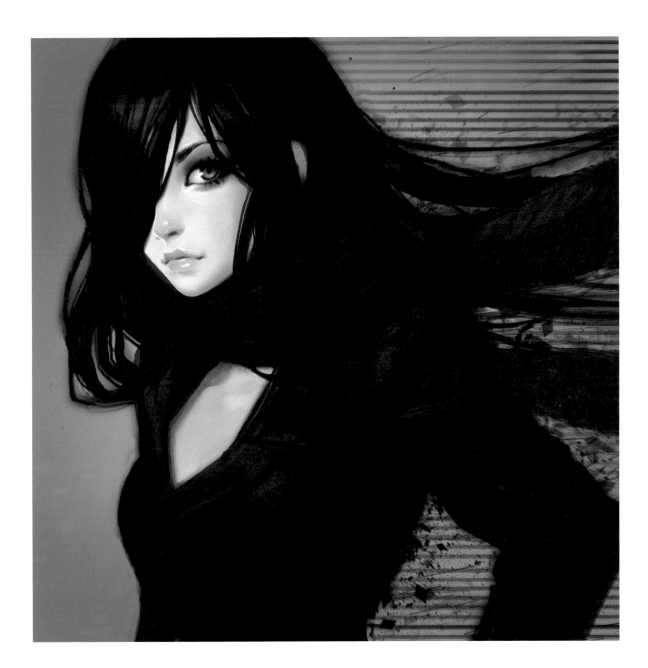

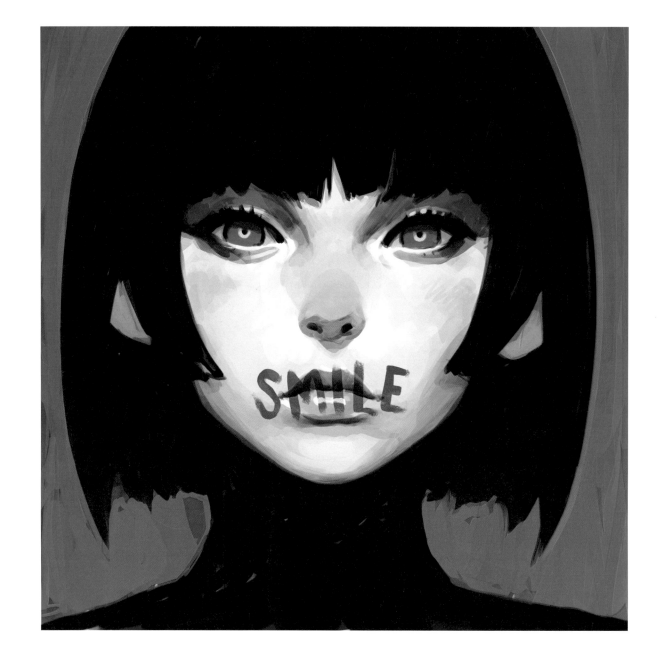

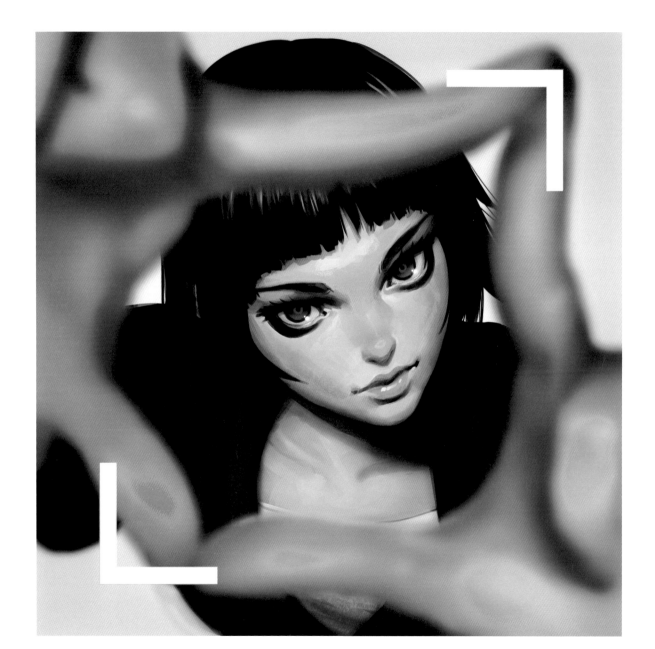

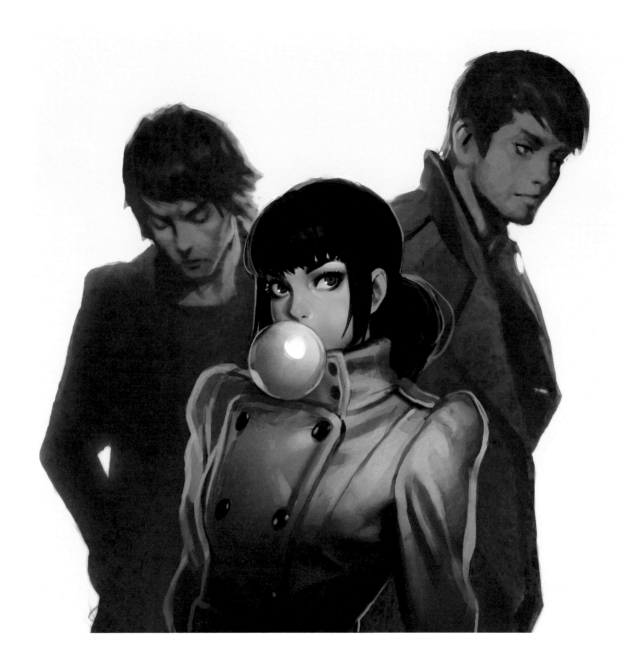

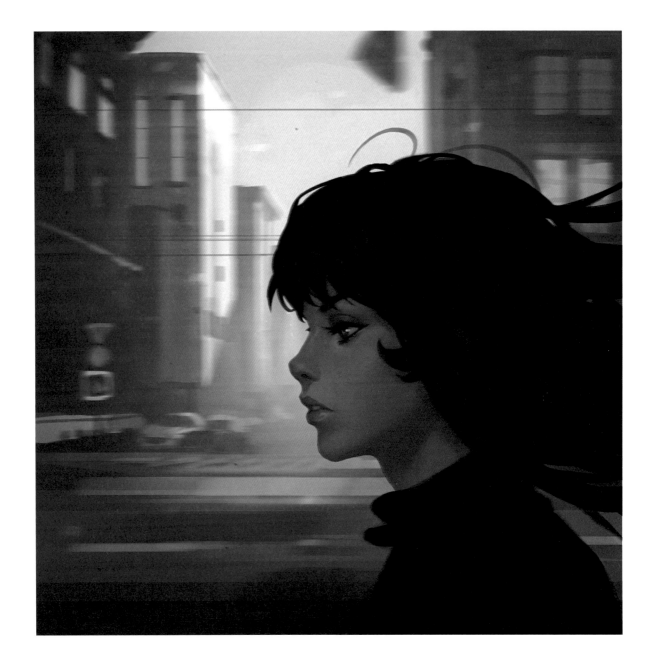

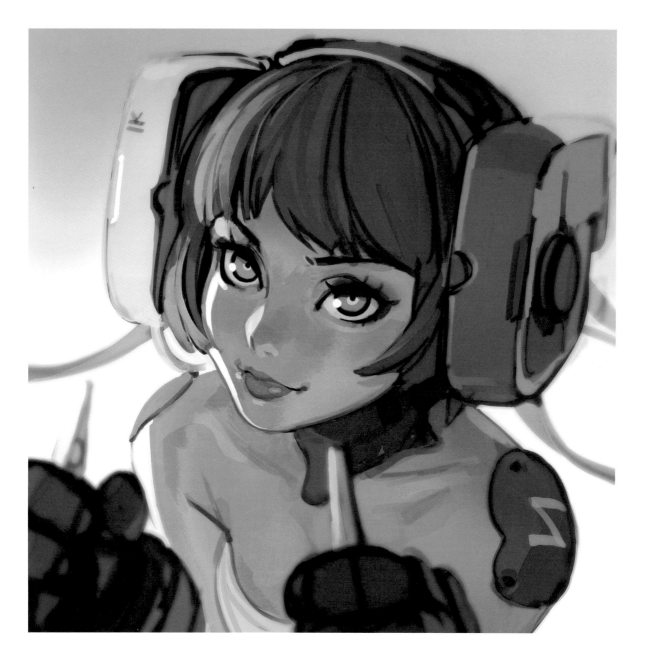

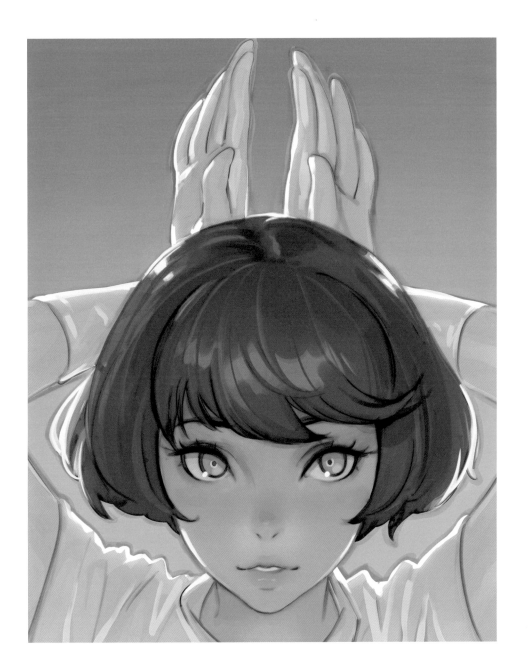

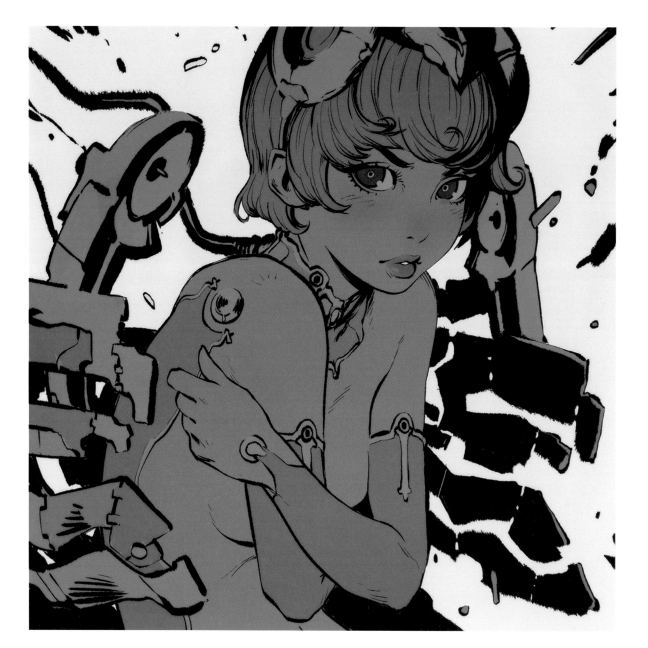

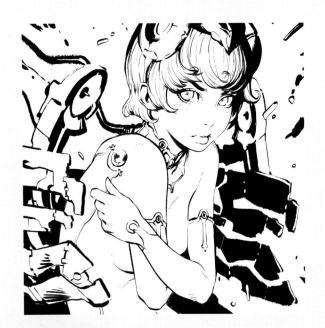
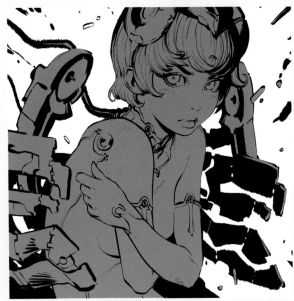

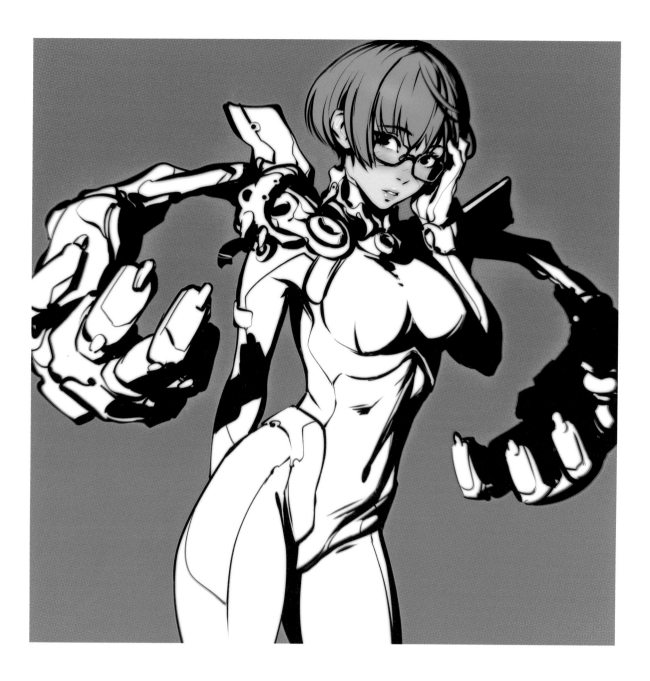

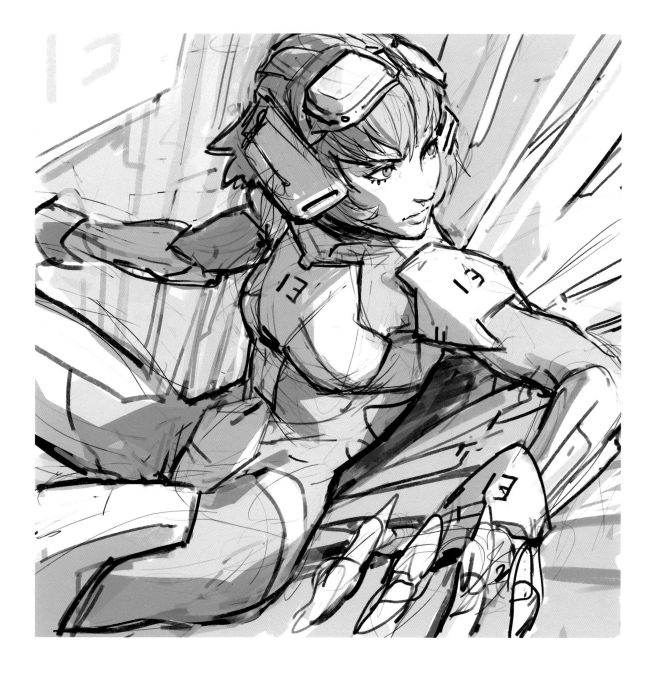

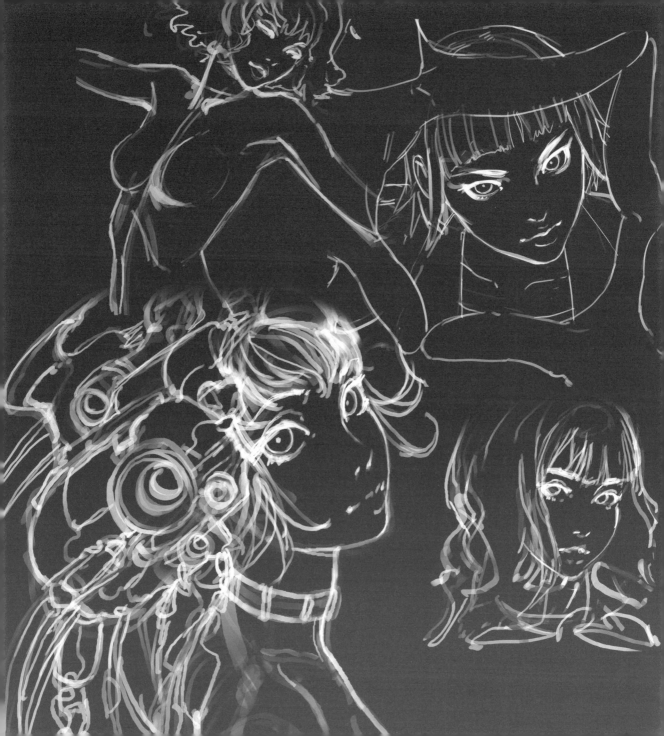

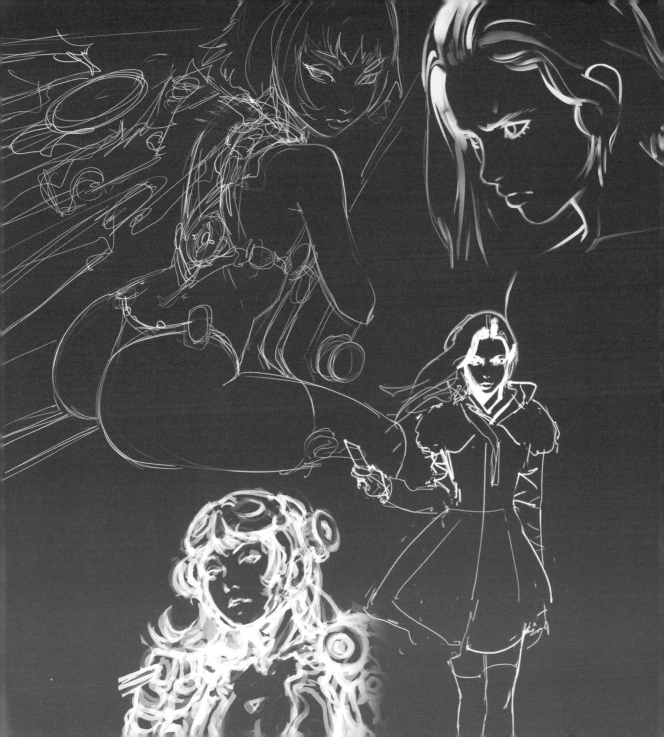

渋谷は私にとって大切な街です。それにはもちろん理由があります。17歳のとき、アートアカデミーの建築学科に初受験したのですが、苦手な数学のせいで不合格になってしまいました。建築学科に入学することしか頭になかった私は、ひどく落ち込みました。

失意の日々を送る私が偶然出会ったのが『すばらしきこのせかい』というゲームでした。このゲームの主人公が試練に直面する様子は、私とまるで同じでした。ゲームの中で仲間と助け合いながら冒険を続けるうちに、私は人生の試練も同じように乗り越えられるものと知りました。『すばらしきこのせかい』の舞台は渋谷です。渋谷にいるときは、いつもこの頃の経験を思い出して前向きな気持ちになります。

Shibuya is my sacred place, I'll share a memory to explain why. At 17, I failed at my first attempt to enter the Art Academy's Architecture Faculty due to my poor math skills. I felt that this failure crushed my plans for the future because at the time I thought Architecture was my only option.

During those dark days, I discovered the game "The World Ends With You". I found my own life's obstacles mirrored by the game's protagonist. Seeing that even through gameplay, challenges could be overcome, I was inspired to keep pressing on and inspiring others in this quest. "The World Ends With You" is set in Shibuya. Now whenever I'm there, I can recall this experience in a positive light.

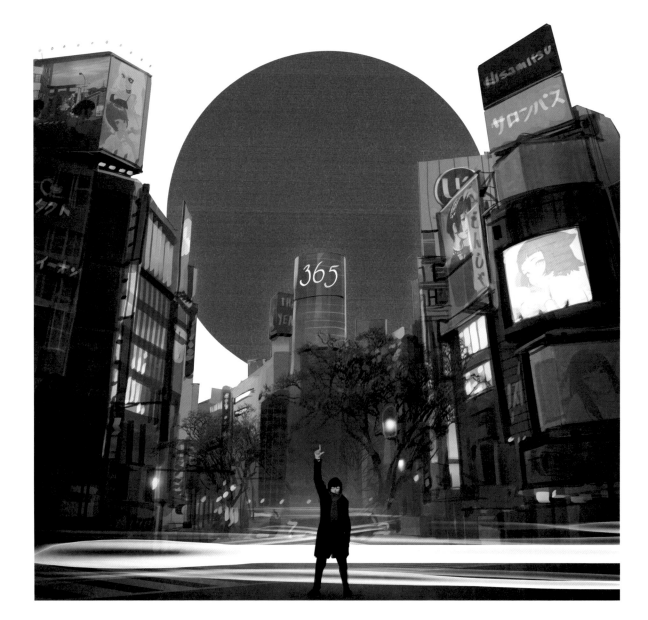

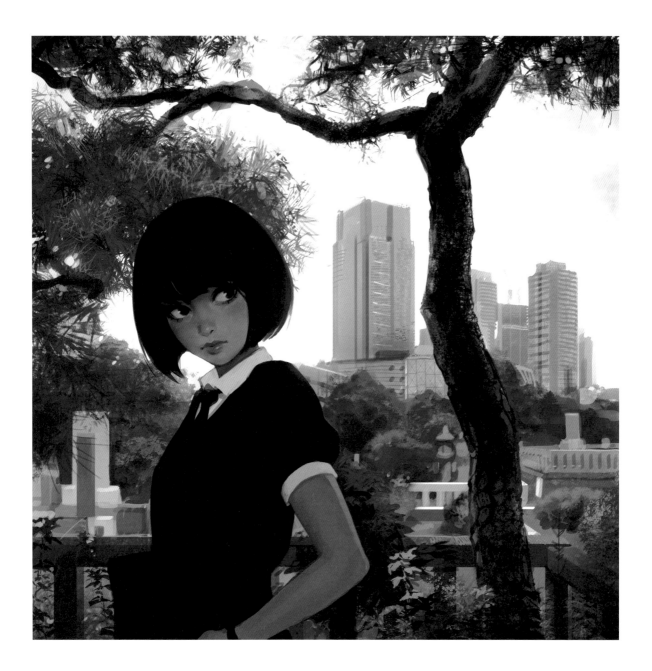

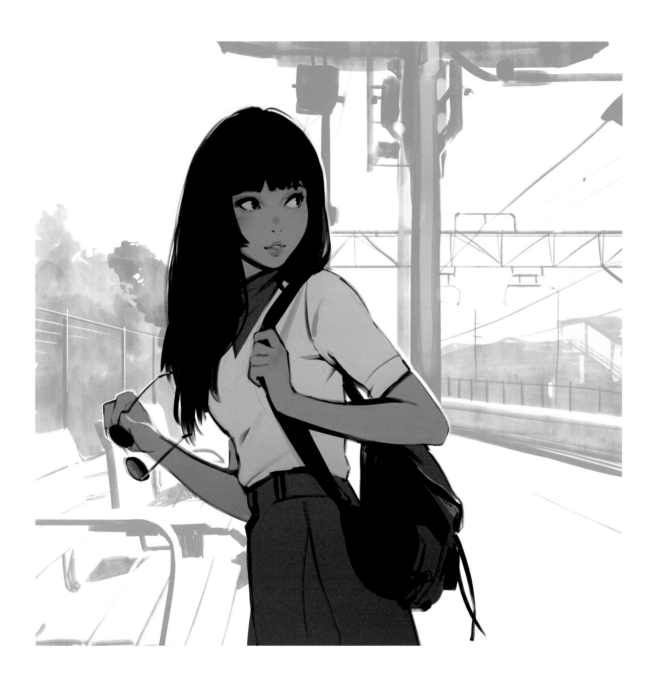

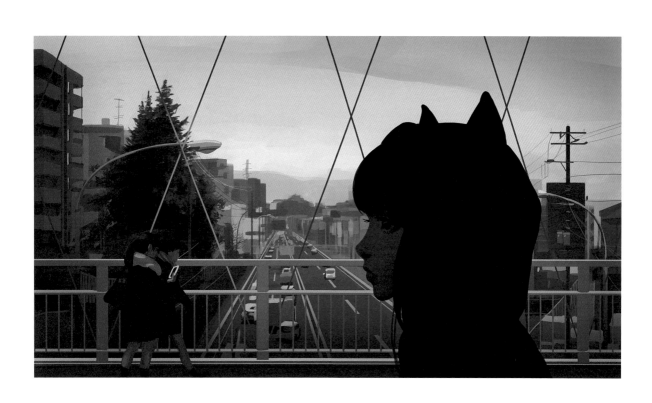

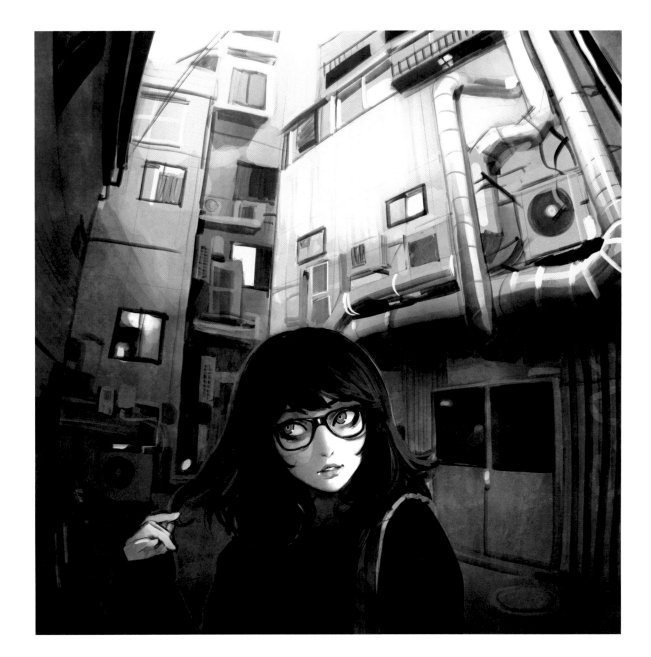

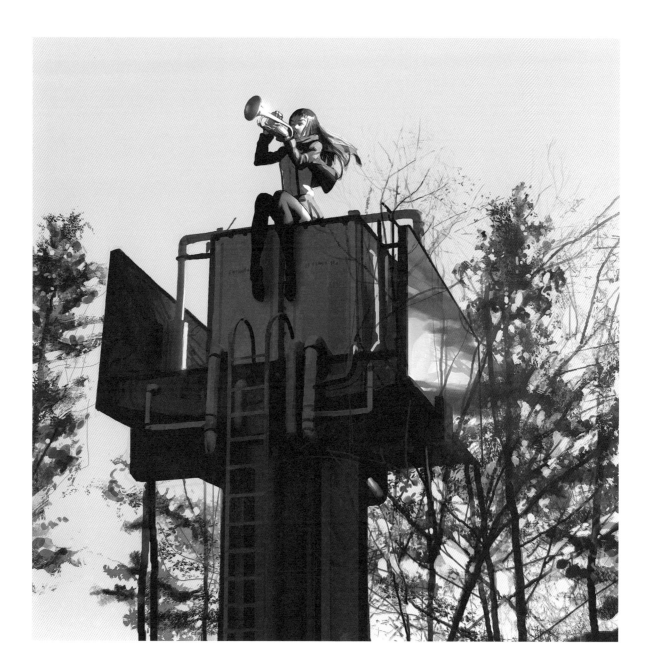

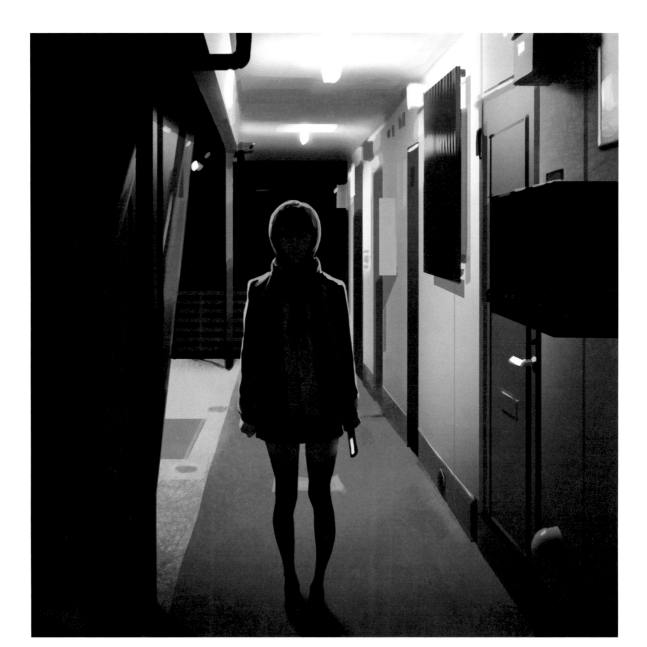

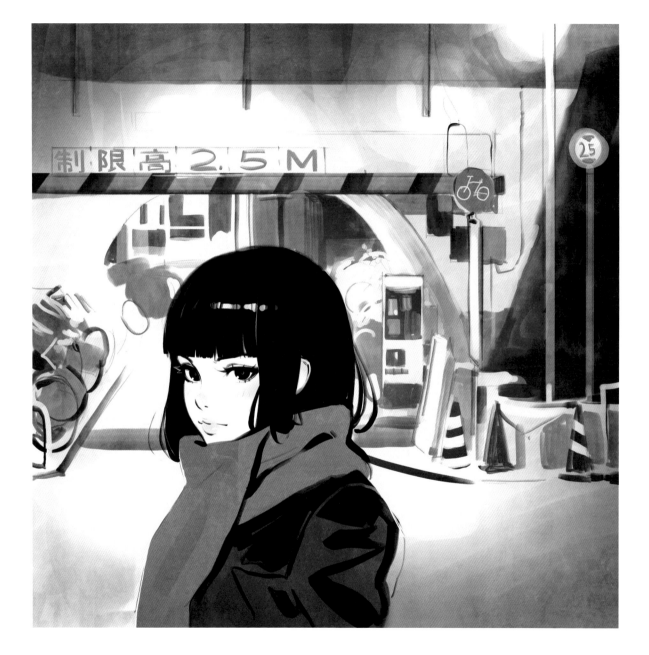

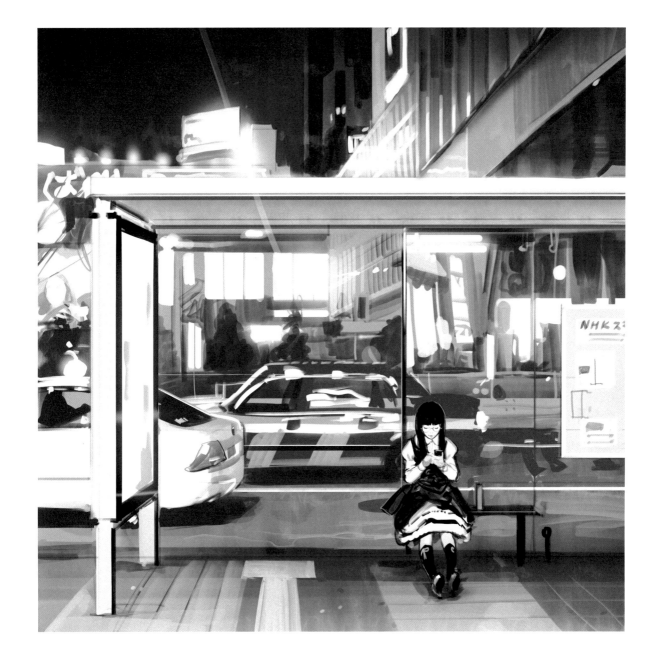

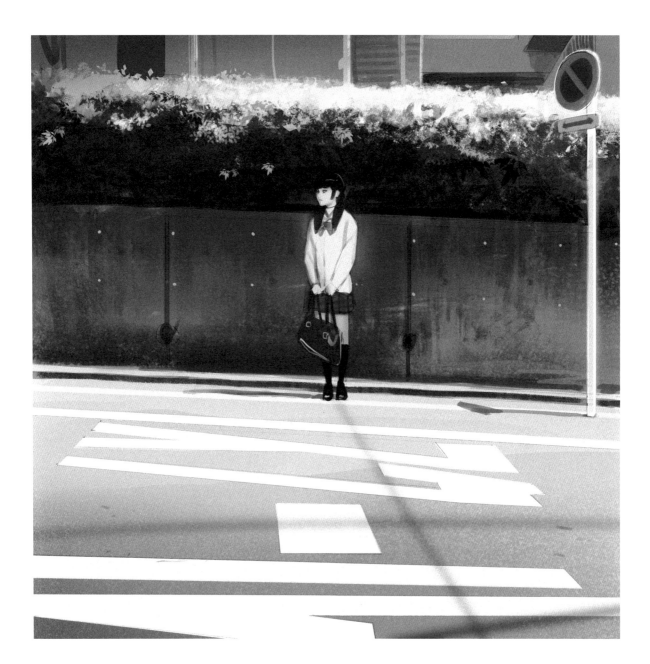

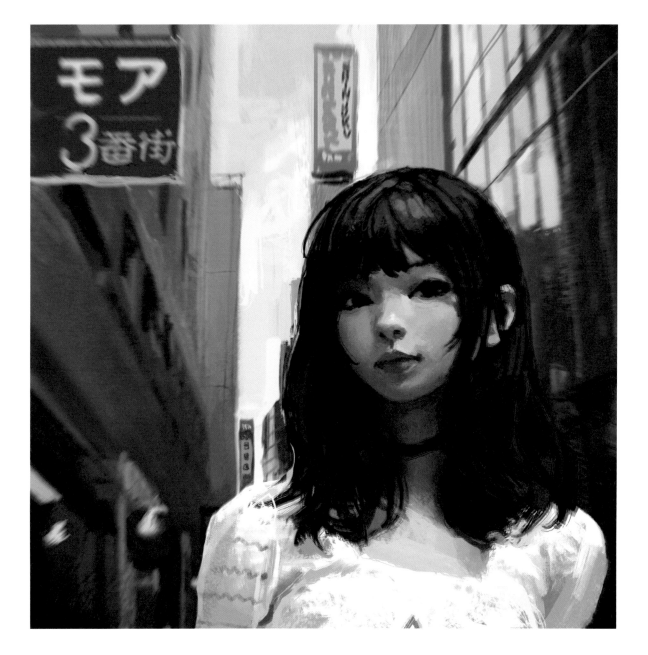

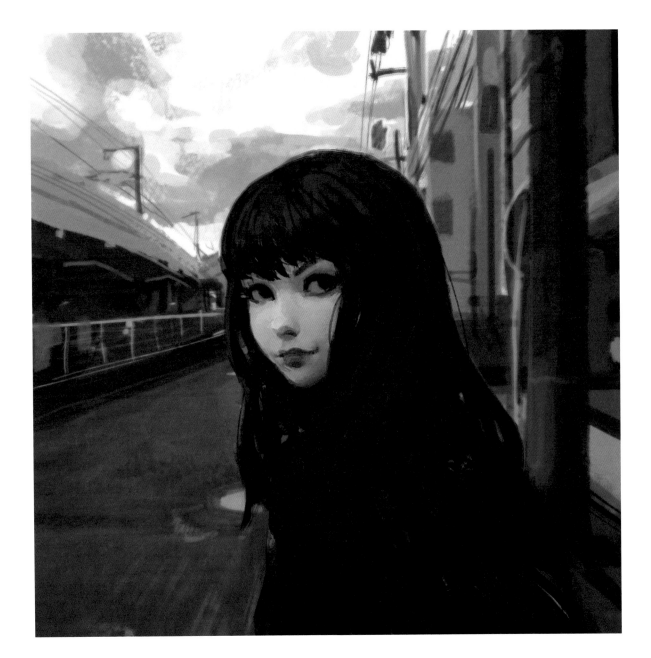

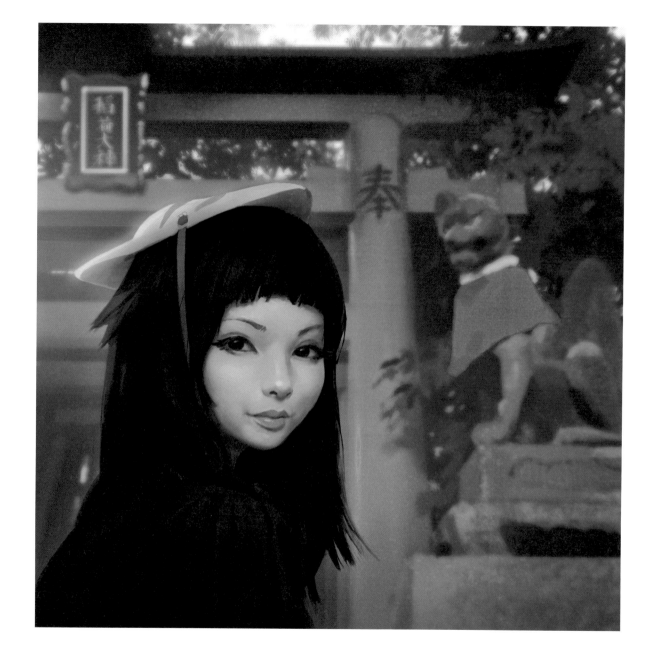

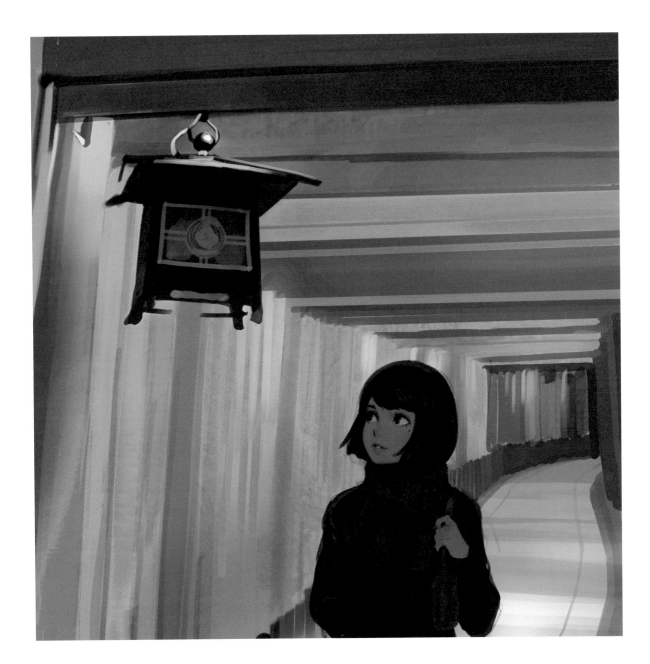

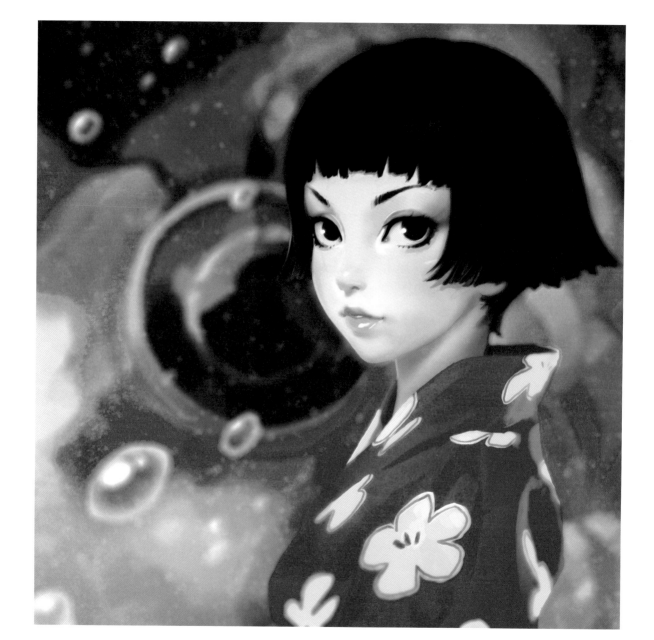

私が通っていた美術学校では、毎週50枚のスケッチを提出するのが課題だったので、長い電車通学の間にスケッチをしていました。乗客一人一人の身体的特徴に目を凝らすことで、人物を平面的にではなく生き生きと、ただ描くのではなく瞬間をとらえるように描くことを学びました。ロシアでいつも人物のスケッチをしていた私にとって、日本はスケッチをしたくなるような人がたくさんいる刺激的な場所です。

ここで私の愛用品を紹介します。スケッチブックはDELETER、MOLESKINE、マルマン、消しゴムはMONO、シャープペンシルは0.7mm PILOT H-327。ぺんてるの各種筆ペンや、三鷹の森ジブリ美術館で買った水彩画セットも使っています。

絵を描くときは、どの段階であっても全体の構成を決めるまでは細部に手をつけないことが大切です。そして、絵の基本的なコンセプトは守りつつも、作品をより良くする新しいアイデアが浮かんだときは、恐れずに今までの作業を切り捨て、方向性を変えるべきです。私の経験が皆さんのお役に立てれば幸いです。

It was a requirement in art school to present our teacher with 50 sketches a week. My lengthy commutes helped me reach that number since there was little else to do to kill time. Observing passengers and their physical traits taught me to portray them in a way that felt tangible and not flat, as if they were being depicted in that moment and not just as a drawing. While I have always sketched people in Russia, I find it exciting that Japan has no shortage of interesting types of people.

My go-to supplies are DELETER, MOLESKINE and maruman sketch books, MONO erasers and 0.7mm PILOT H-327 Mechanical Pencils. I use various Pentel brush pens and also a watercolor set that I bought at the Ghibli Museum in Mitaka.

At any stage of drawing, it helps to refrain from adding details until you've finalized the composition. Try your best to preserve the general idea of the piece, but don't be afraid to change directions if new ideas better support the goal of your artwork. I've learned this from my own experiences and hope that sharing this knowledge can help others, as well.

5/6

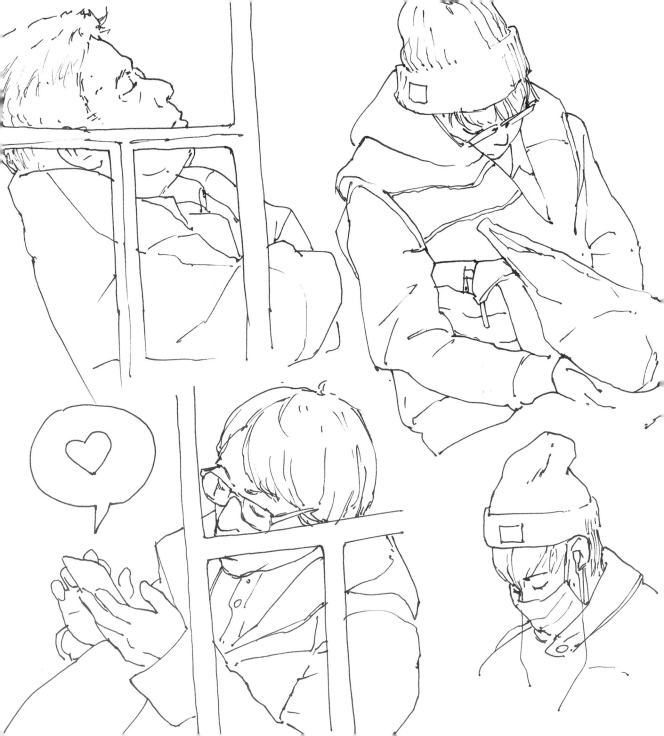

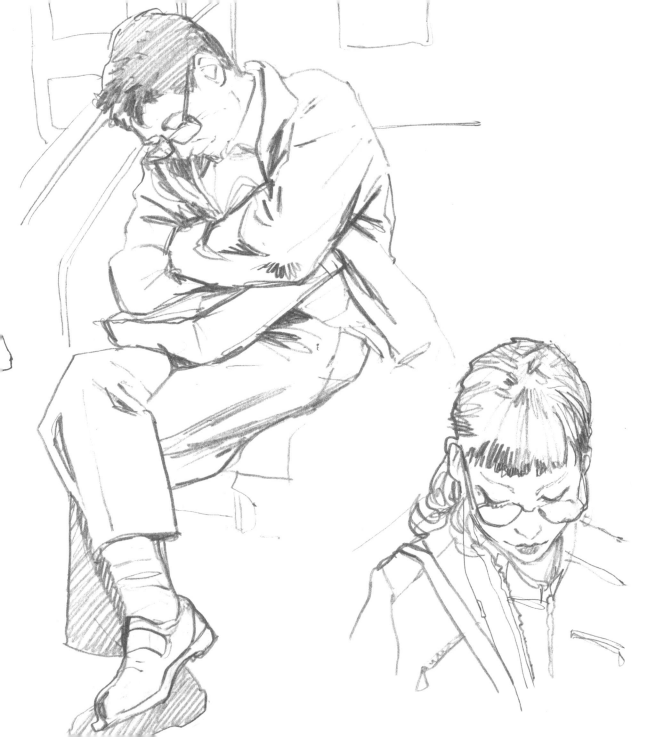

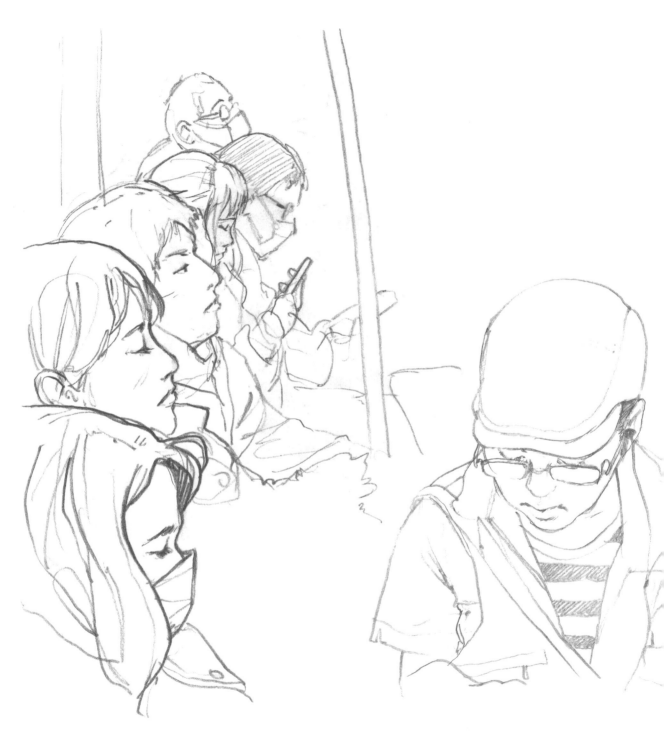

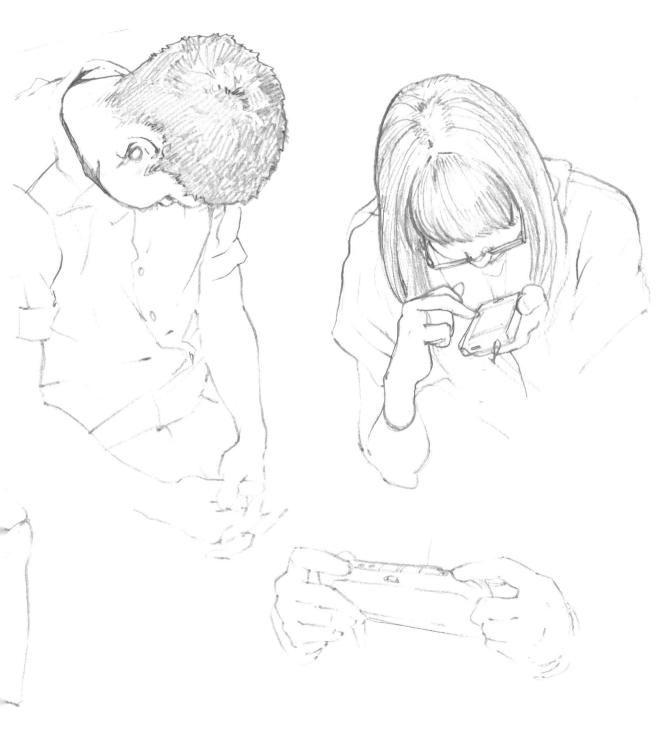

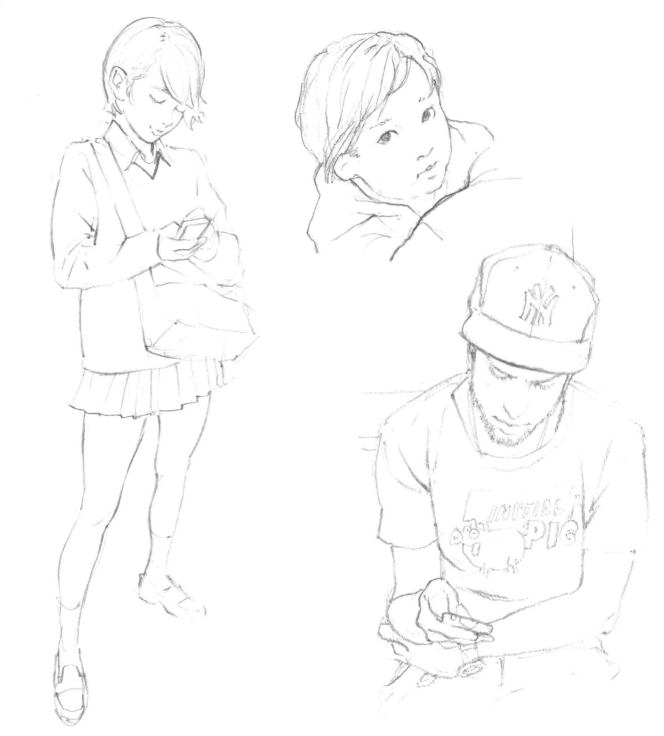

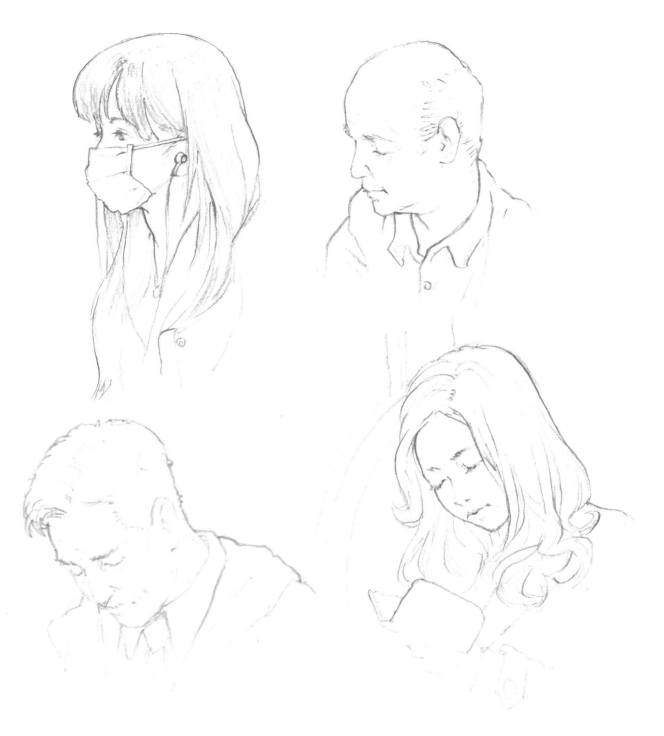

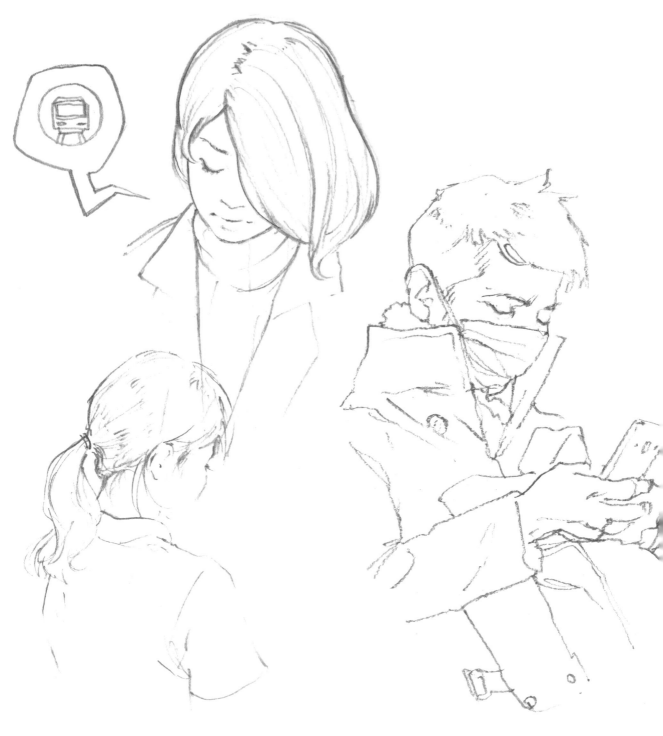

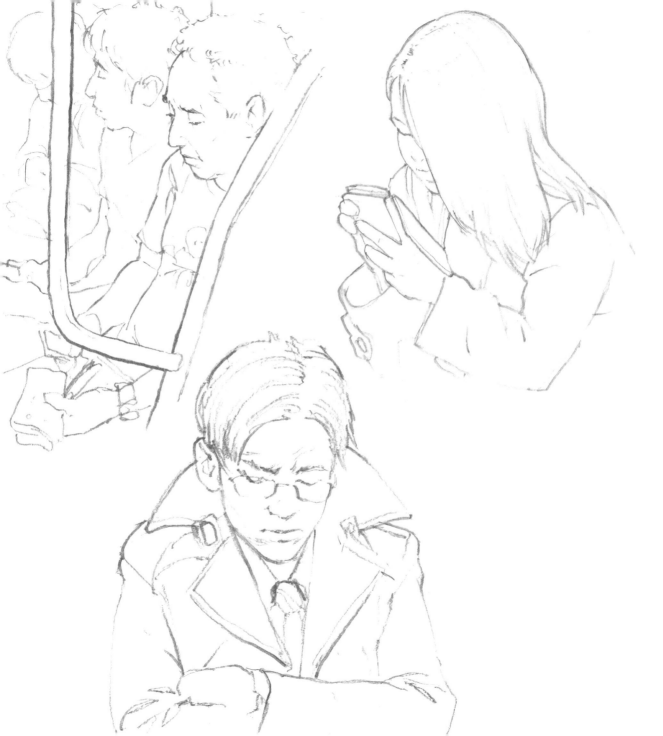

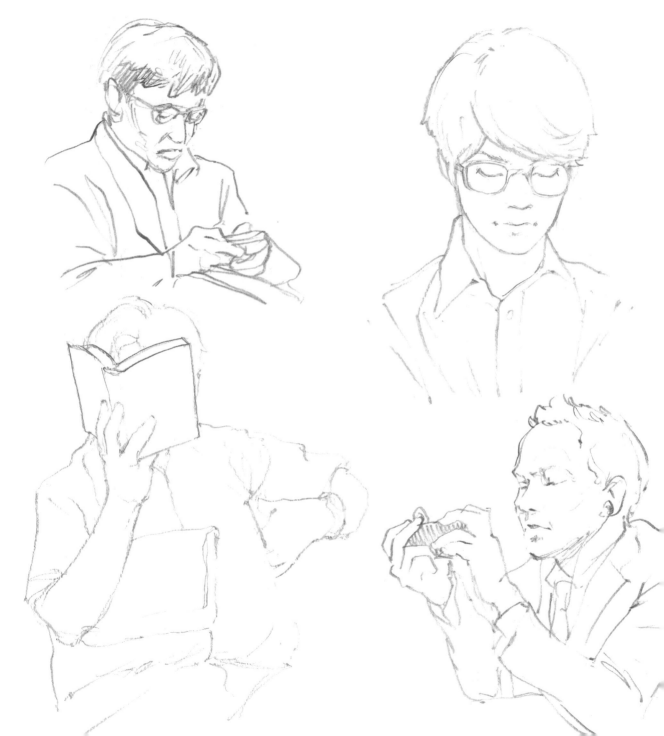

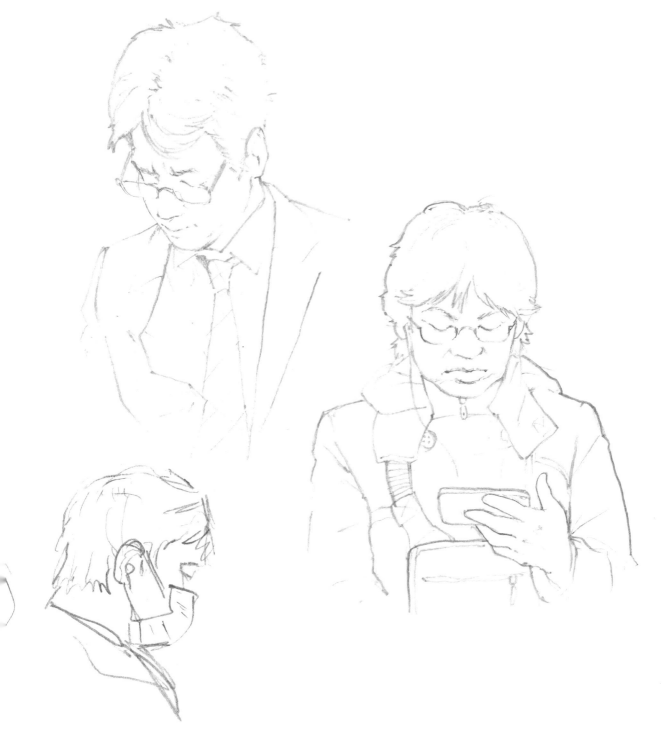

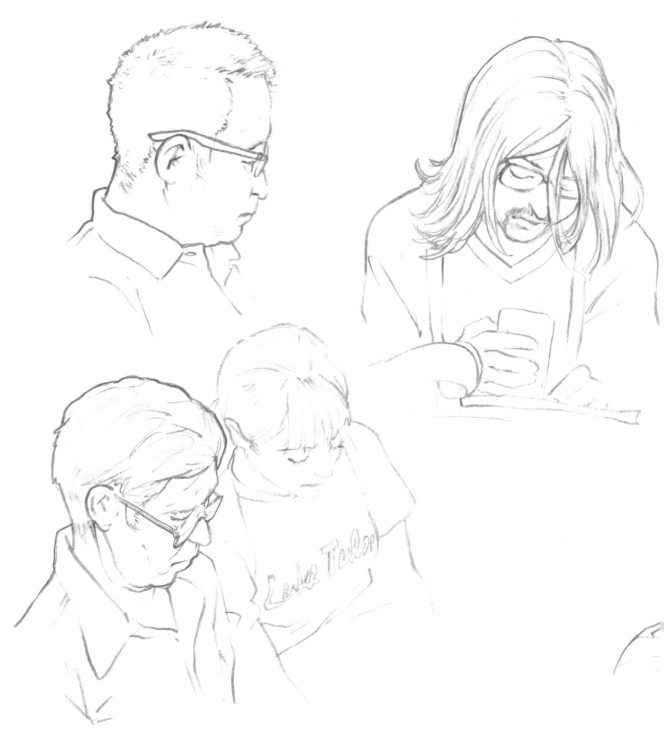

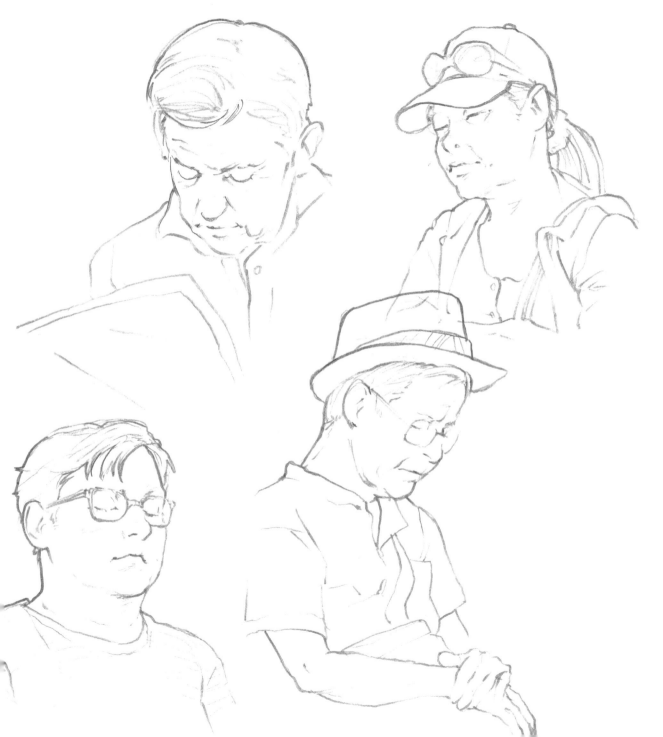

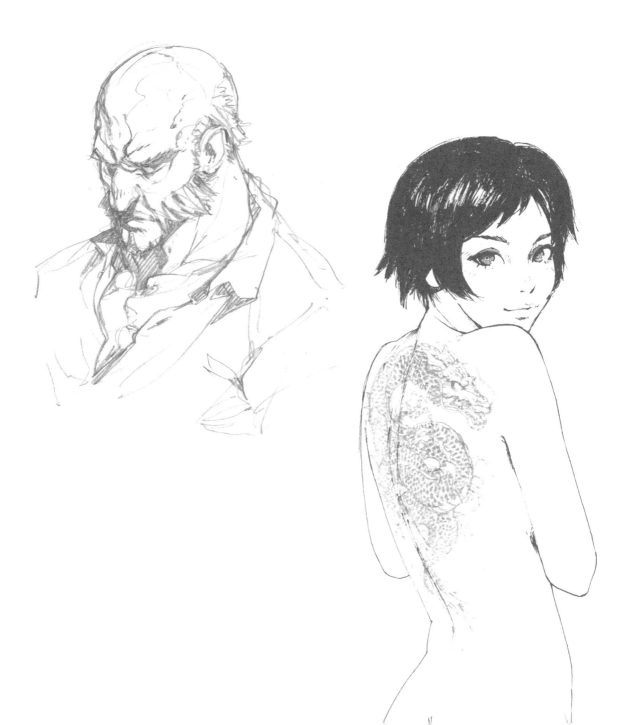

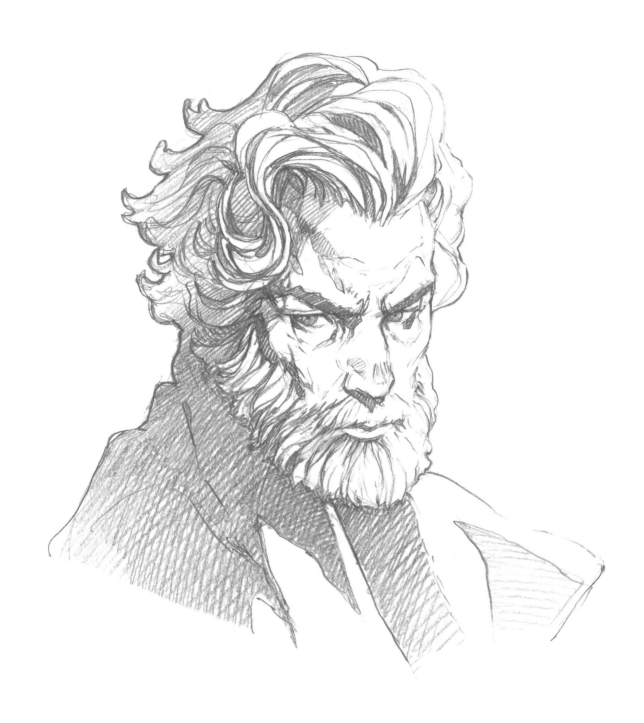

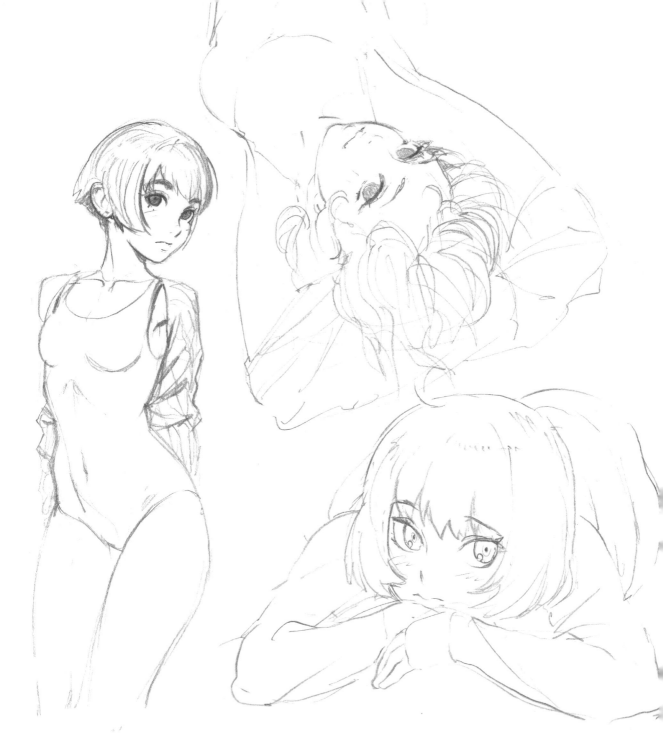

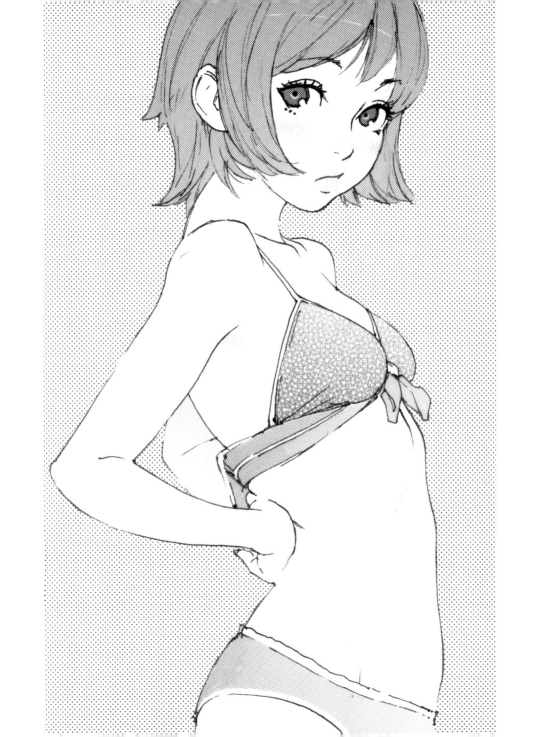

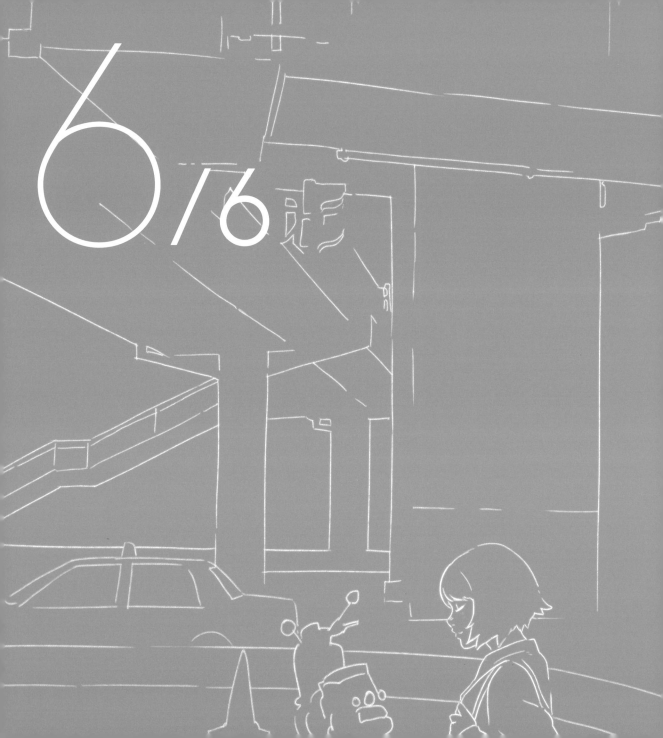

この作品集は、絵に対する私の愛の結晶であると同時に、物語性の
ある作品を作るという私の夢への出発点でもあります。しかし、それ
以上に私にとってこれらのイラストは、見る人をキャラクターに感情
移入させ、感動を共有していくための媒体なのです。私が目指すの
は漫画、映画、ゲーム、もしくはそれらが全部融合したものになるか
もしれませんが、いずれにせよ、たくさんの人に勇気を与える作品を
作りたいと願っています。

『すばらしきこのせかい』や冬目景の『イエスタデイをうたって』は私
を絶望から救ってくれました。彼らが私にしてくれたように、私も作
品を通して、自分の力を信じて前向きに生きることを伝えていきた
いと思っています。

初めての作品集となるこの本を見てくれてありがとうございます。こ
の本は、三年間毎日絵を描き続けてきた私の集大成です。どんな暗
闇の中にいても自分を信じてください。それが私の人生経験そのも
のであるこの作品集に込められたメッセージです。

すべて失敗したとしても、自分の心にだけは正直でいてください。

On their own, this collection of illustrations represents my love for
drawing and my goal to create narrative-driven art. But beyond this,
they are a means for me to move my audience through characters that
connect with them on an emotional level. Whether it's through manga,
movies or video games - or even a combination of all three - my work
aims to empower people.

Titles such as "The World Ends With You" and Kei Toume's "SING
YESTERDAY FOR ME" saved me when I had lost all hope. To honor them,
I want my work to inspire people to believe in their own strength and
ability to move forward in life.

Thank you for looking at my first art book. This book is the result of my
drawing daily for the past three years of my life. I hope this illustrated
collection of my life experiences remind you to always believe in yourself
even in your darkest moments.

When all else fails, always stay true to yourself.

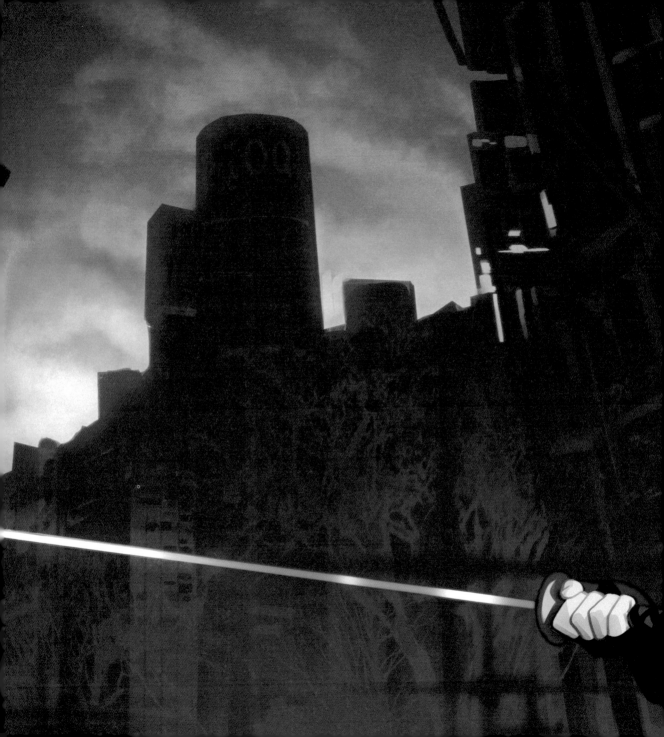

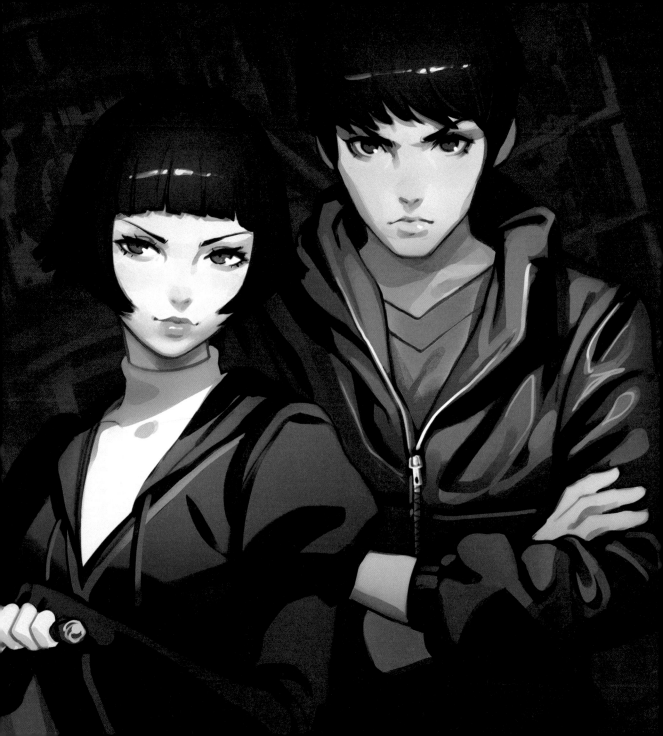

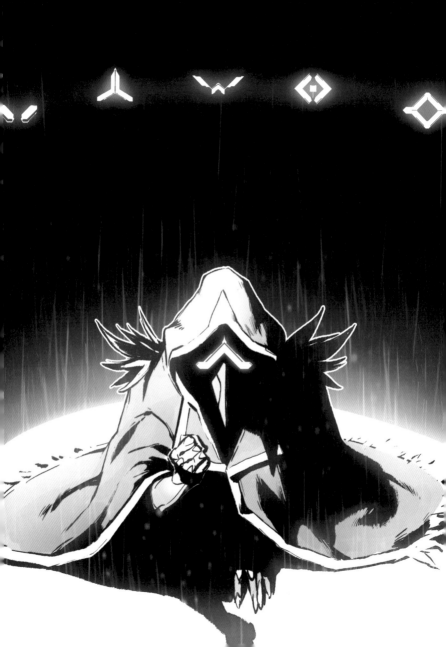

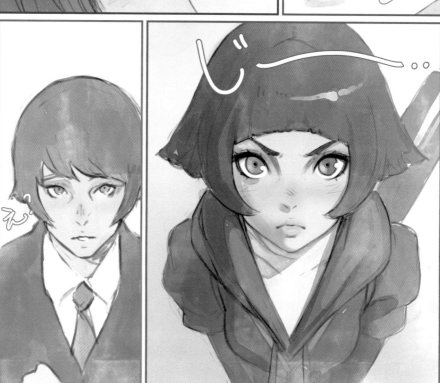

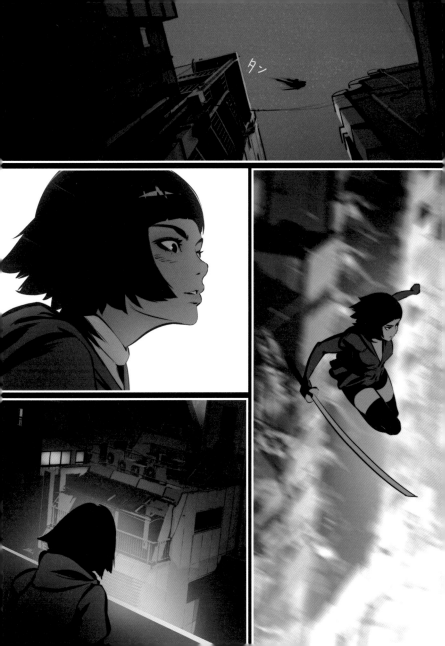

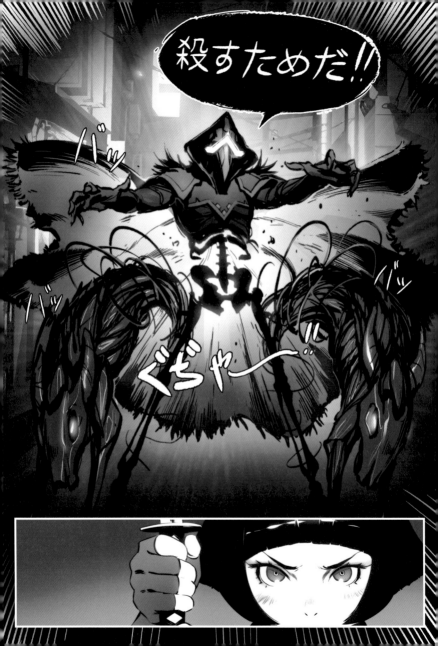

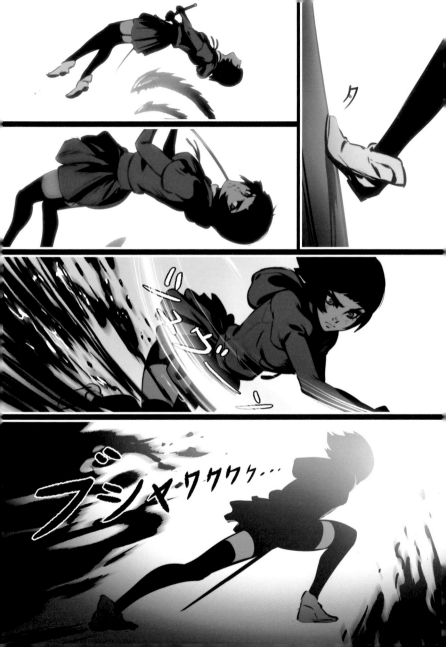

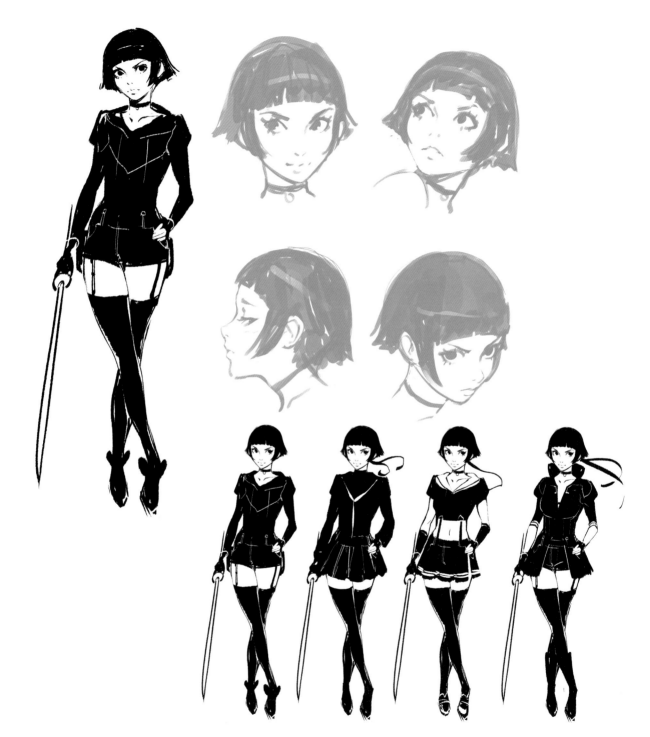

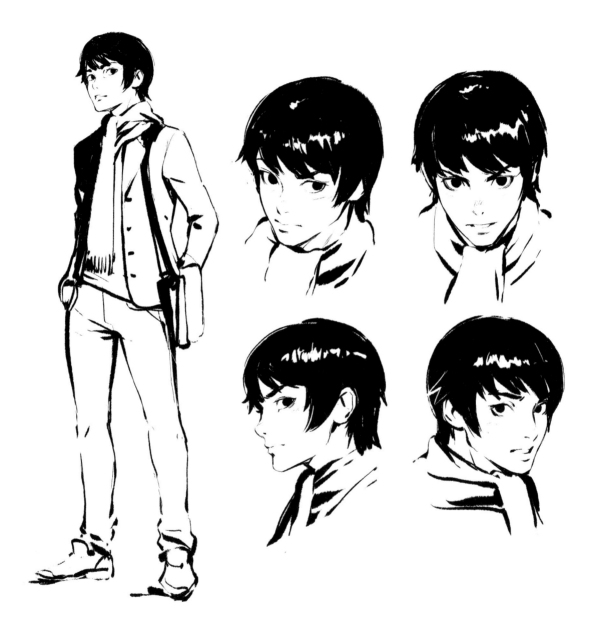

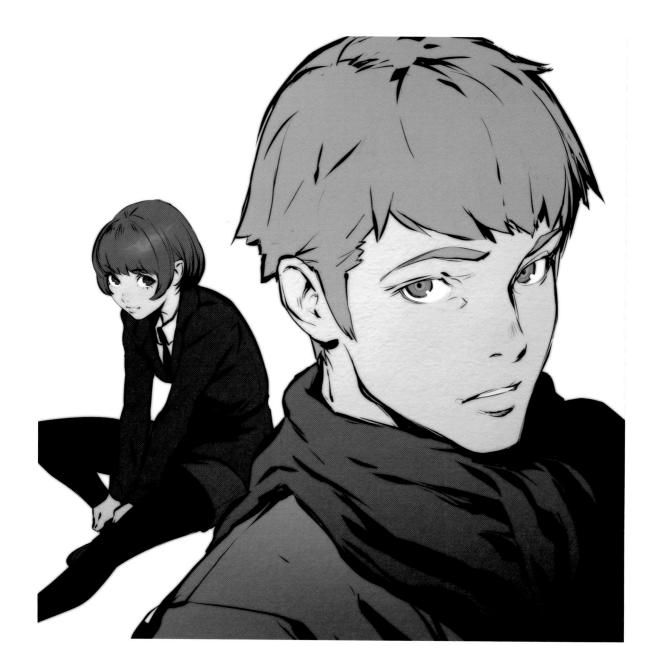

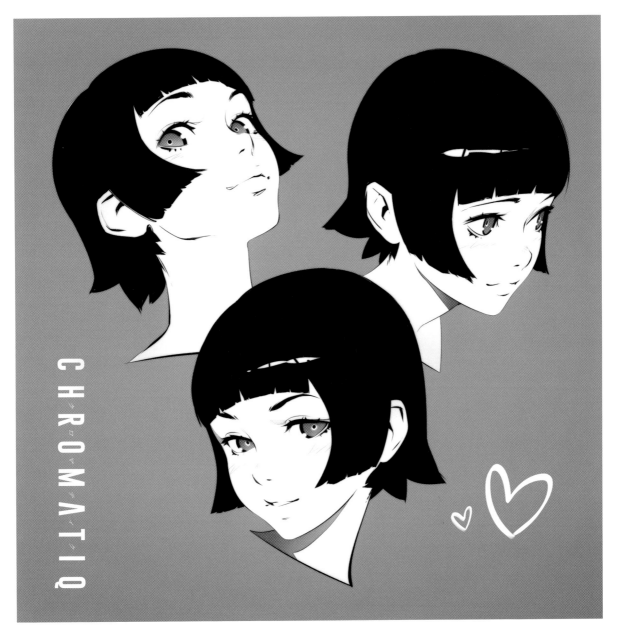

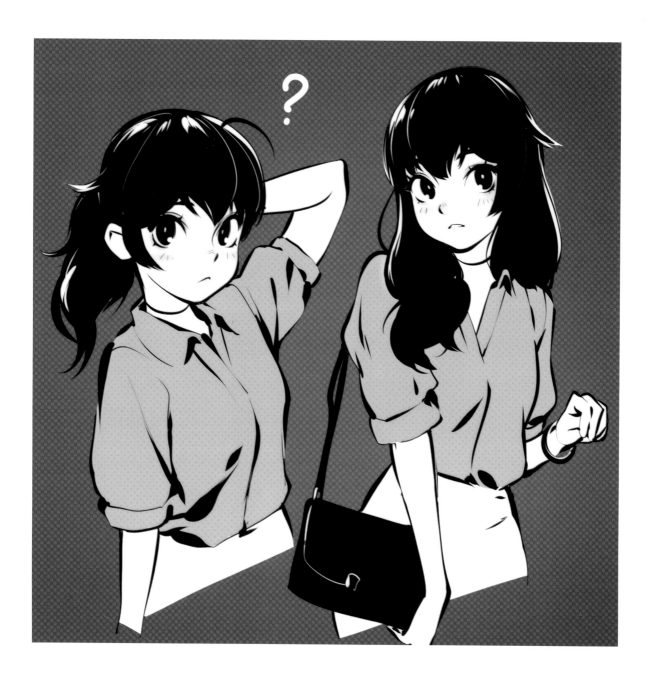

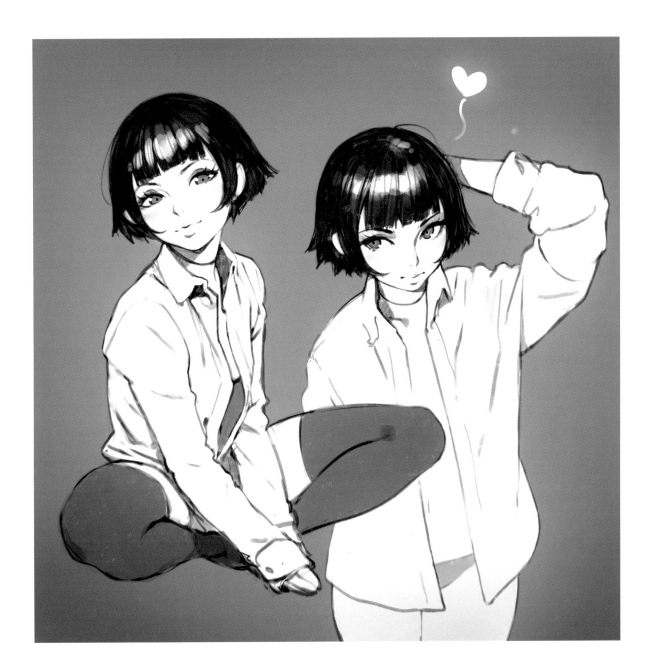

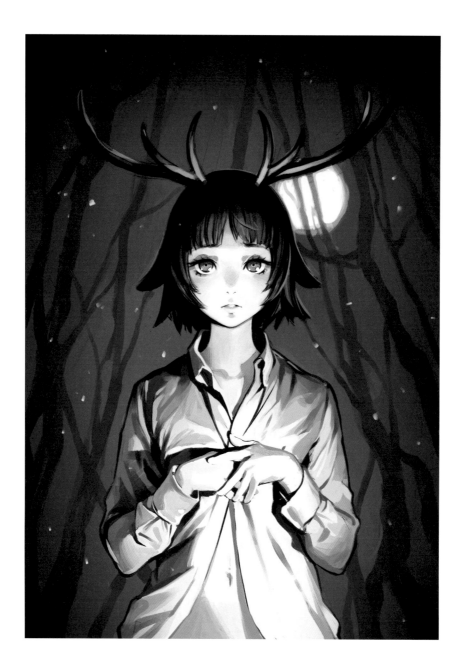

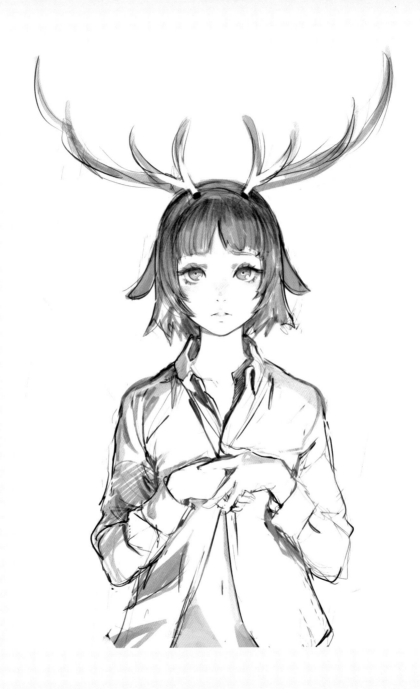

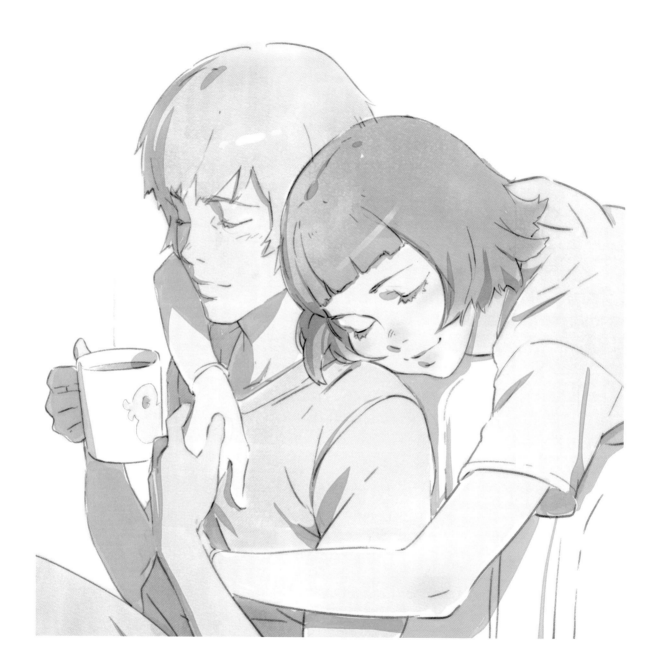

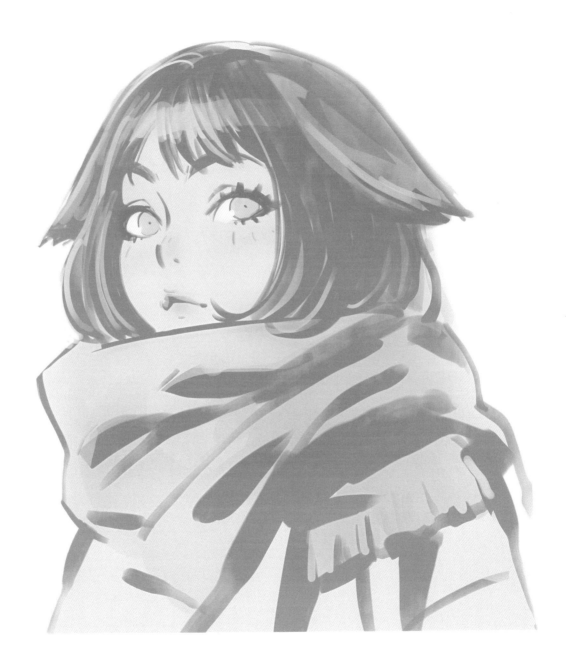

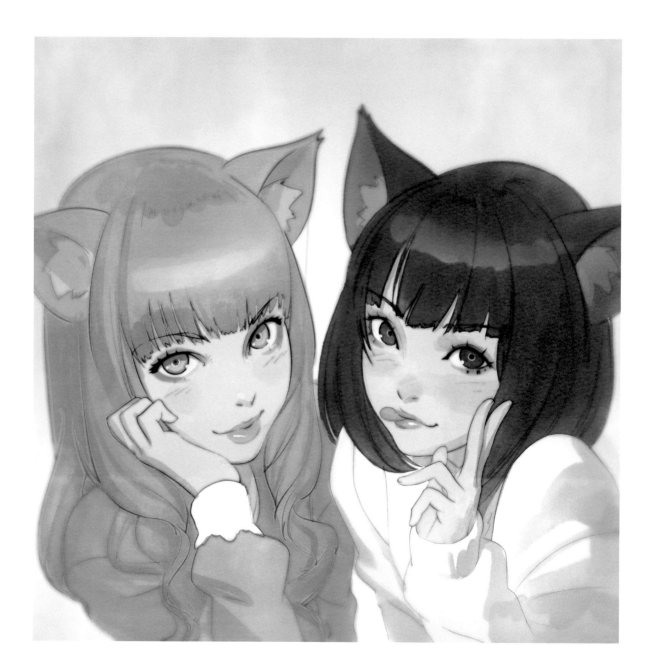

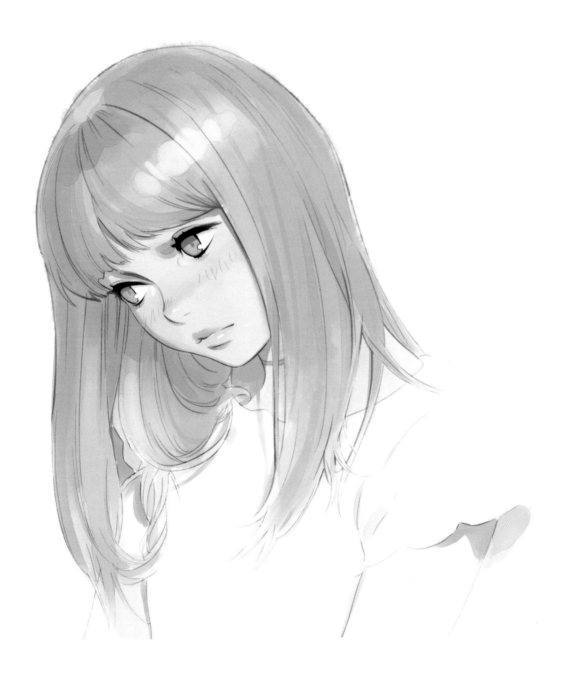

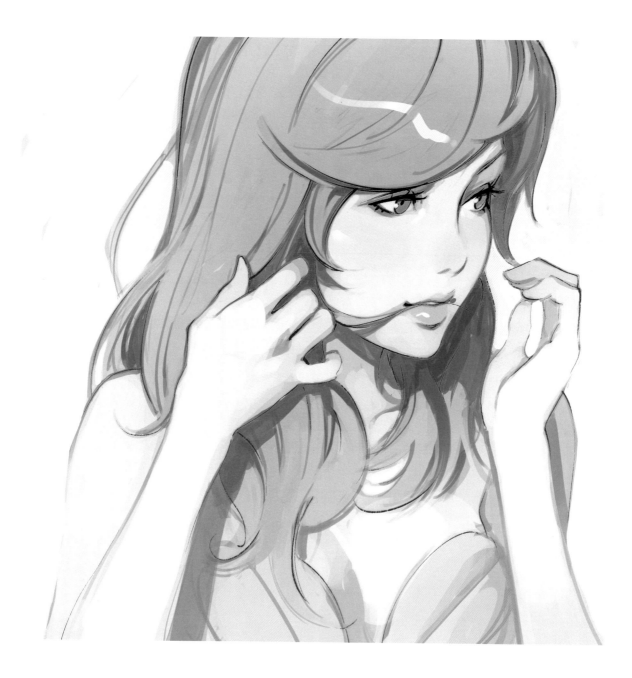

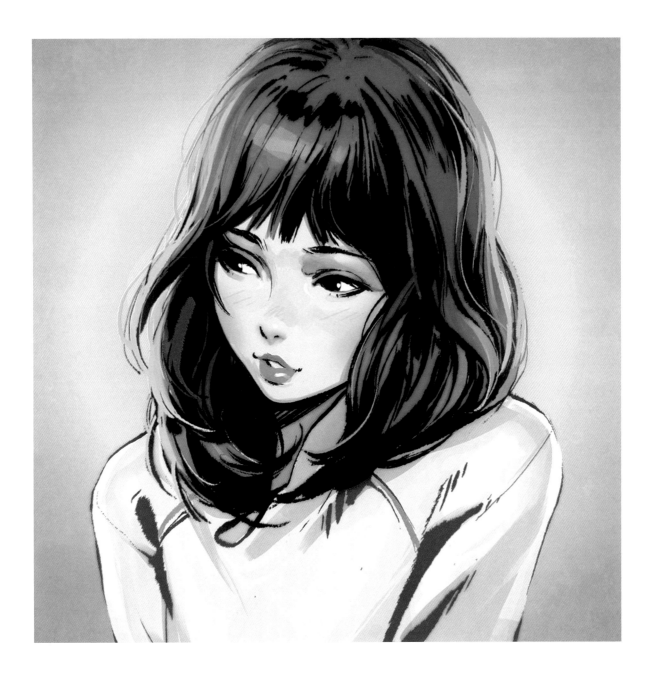

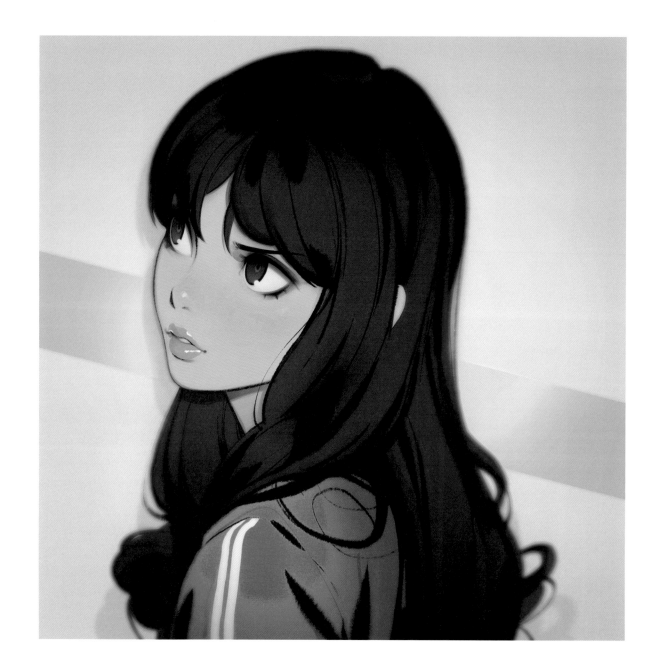

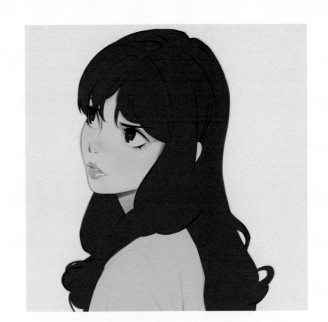
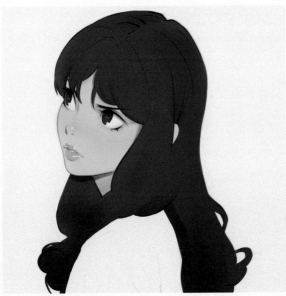
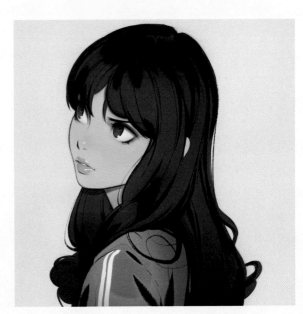

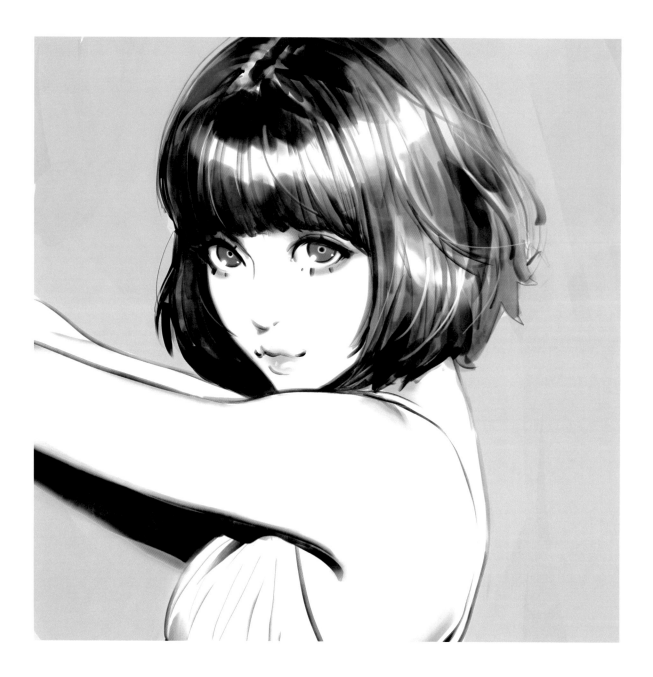

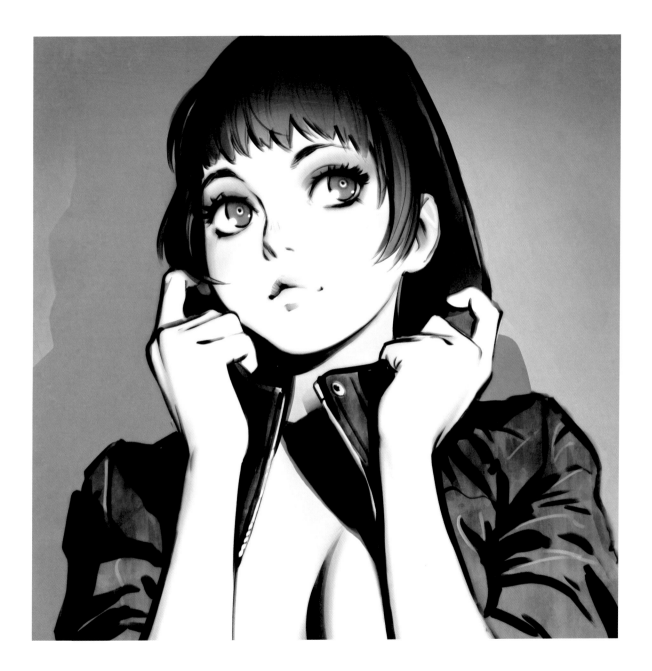

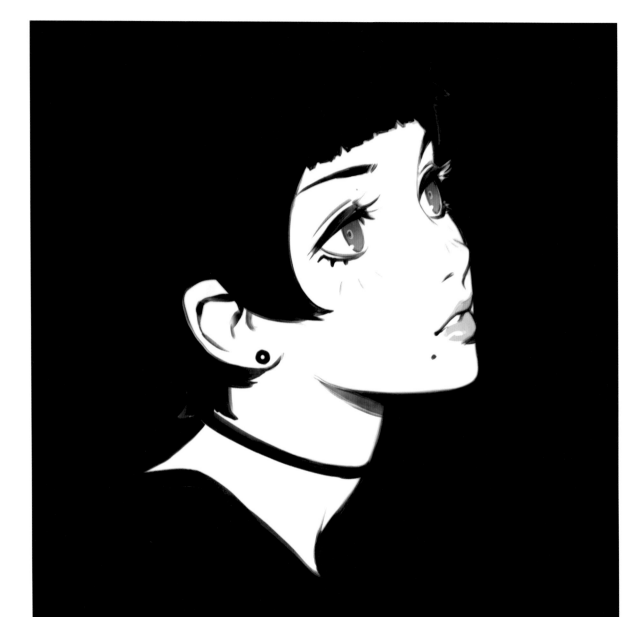

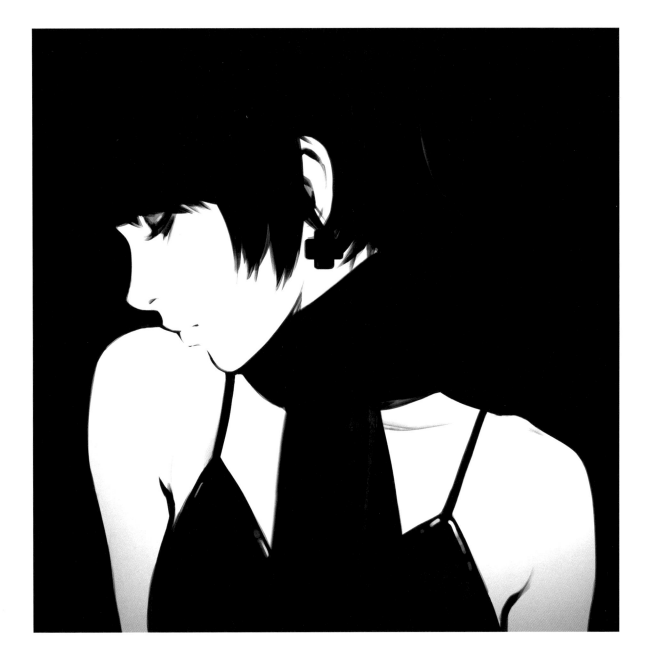

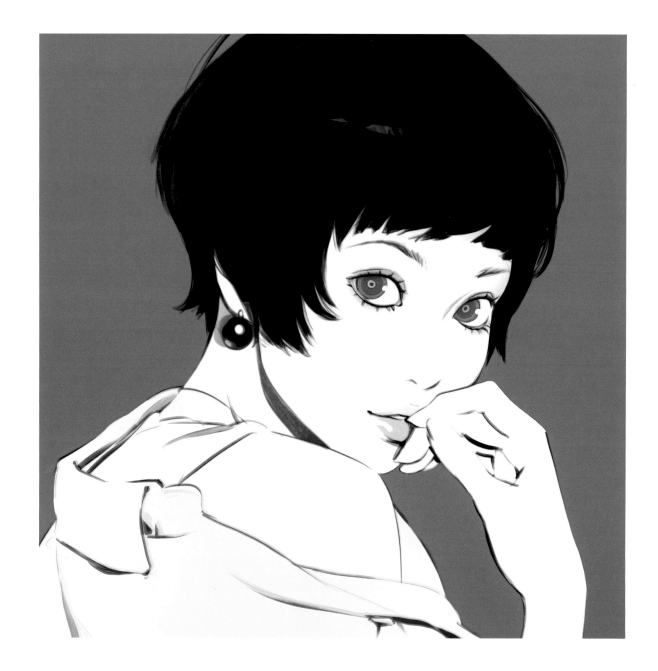

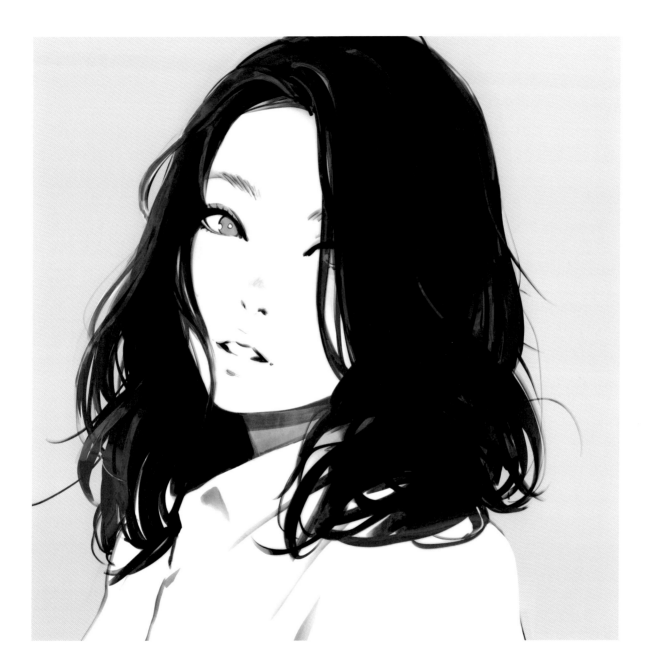

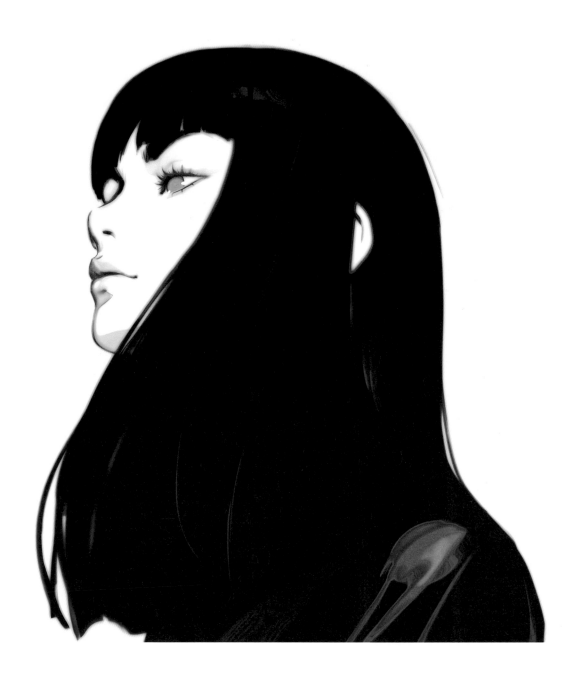

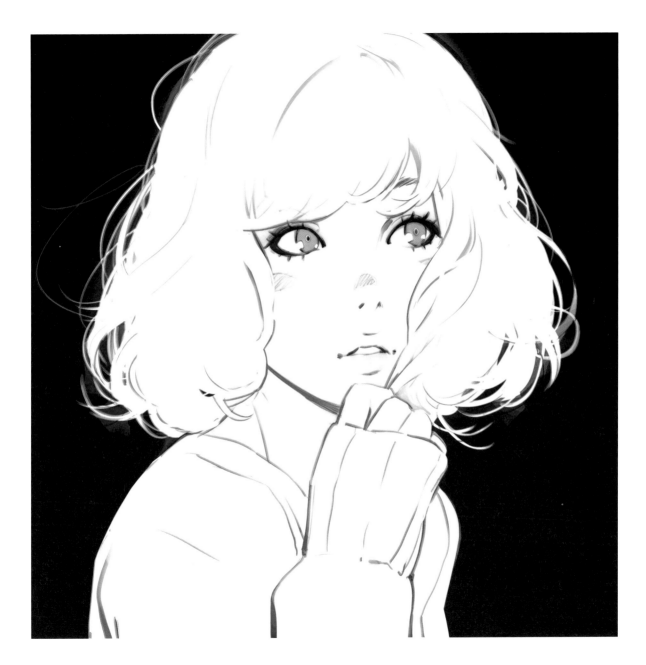

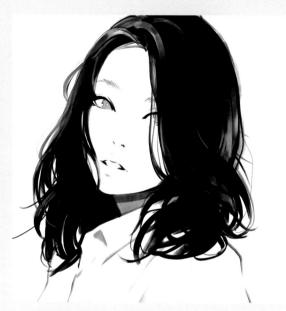
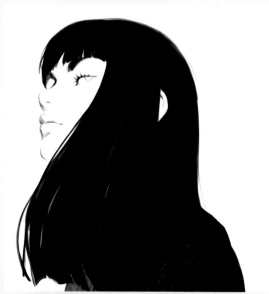
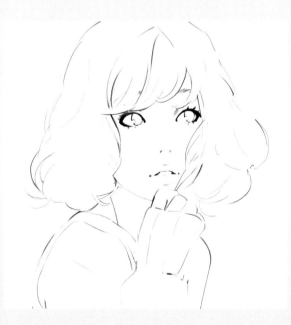

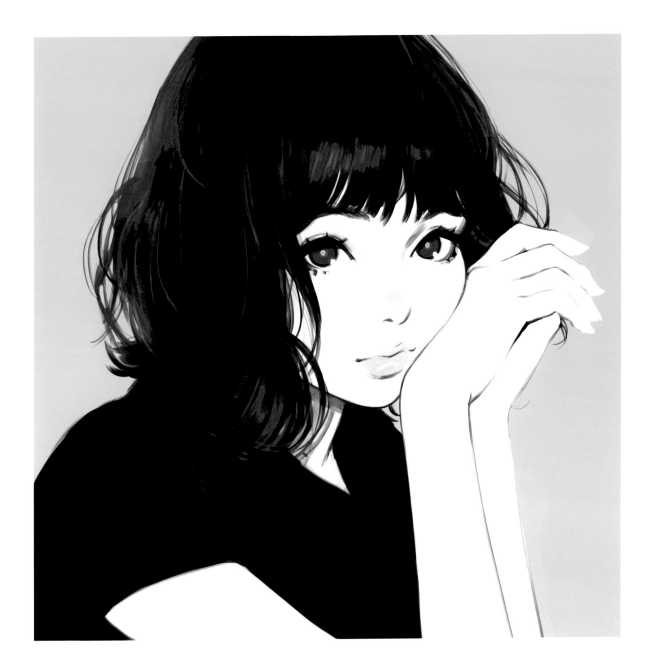

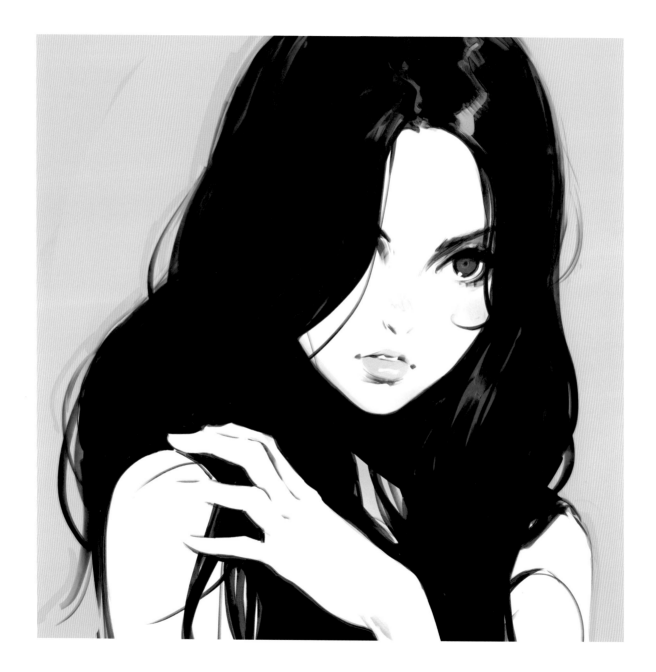

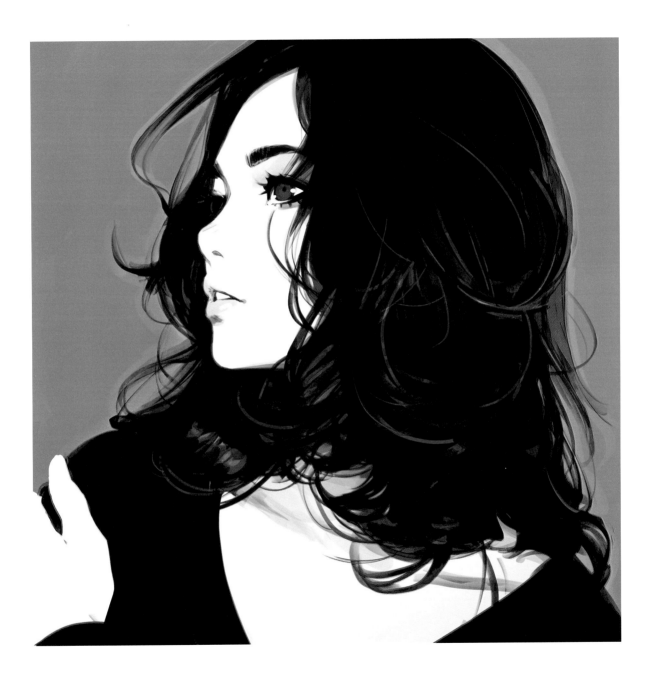

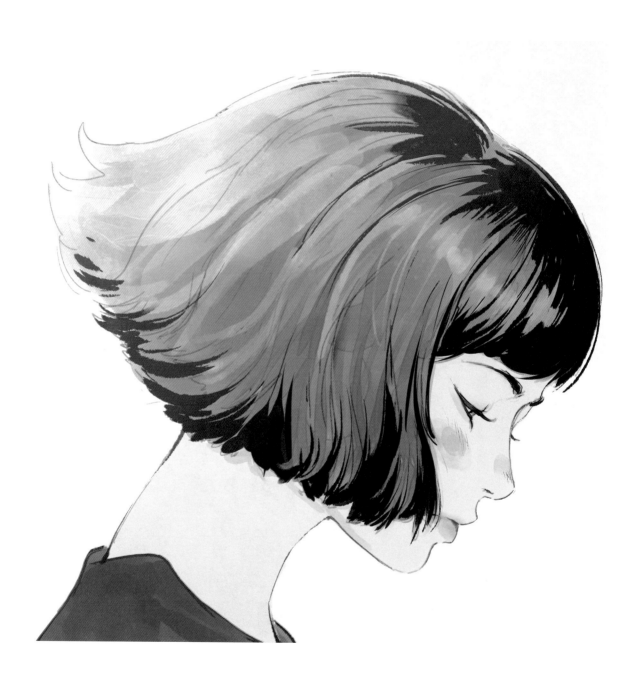

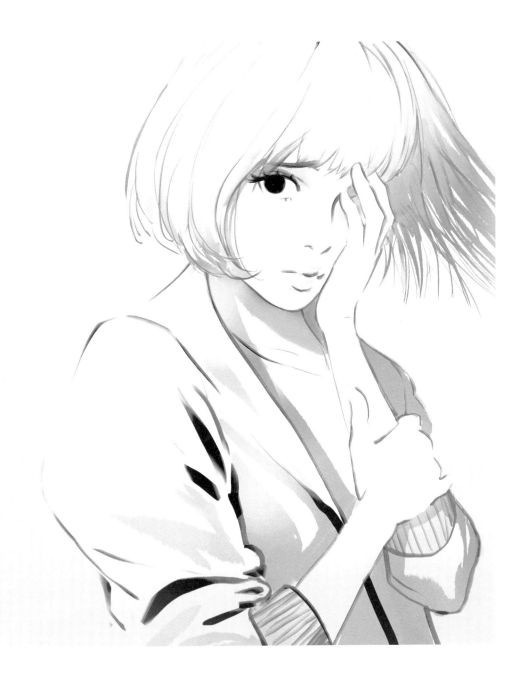

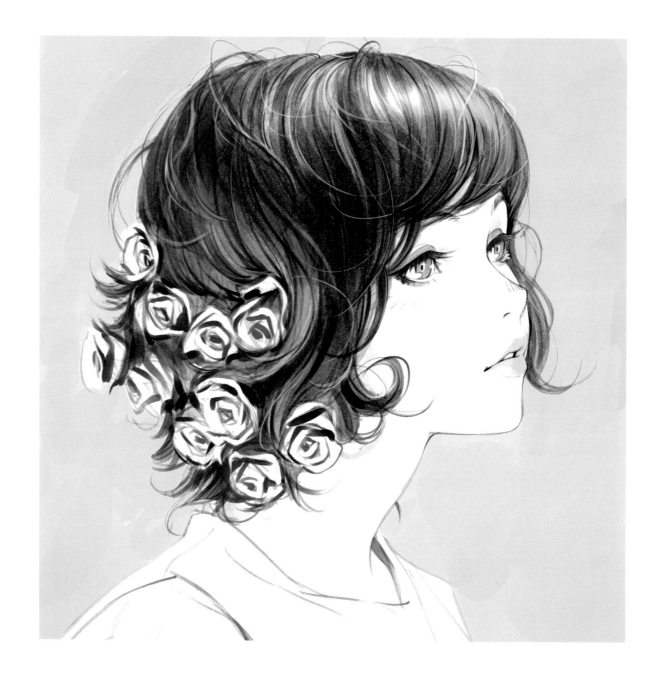

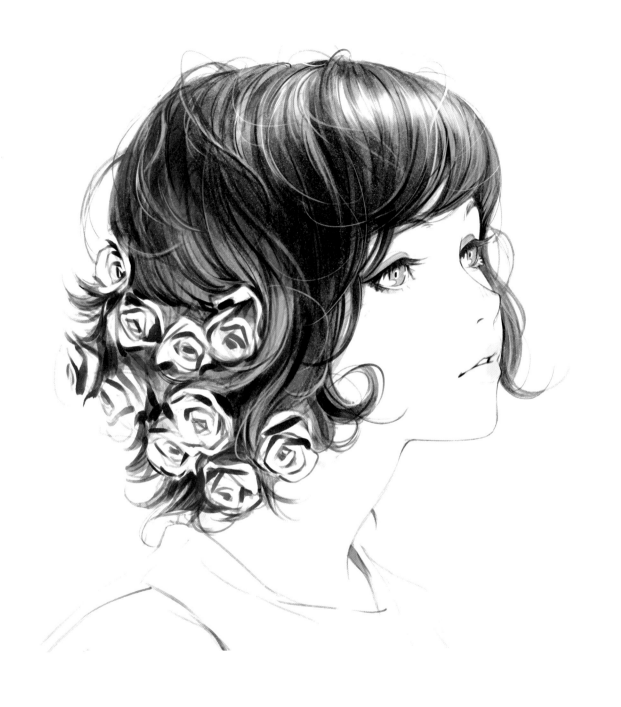

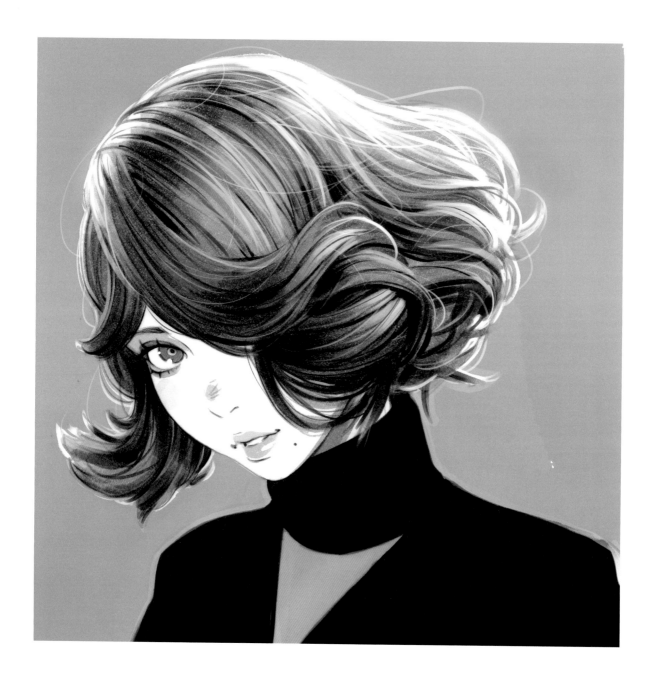

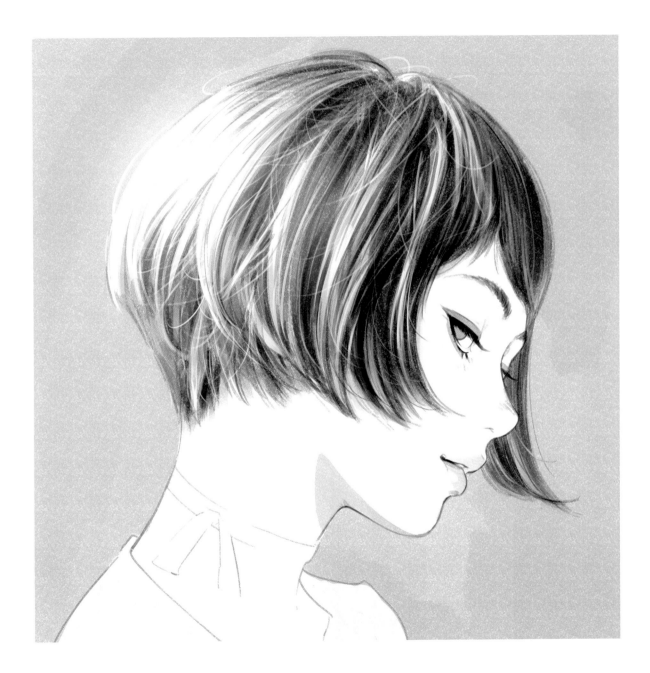

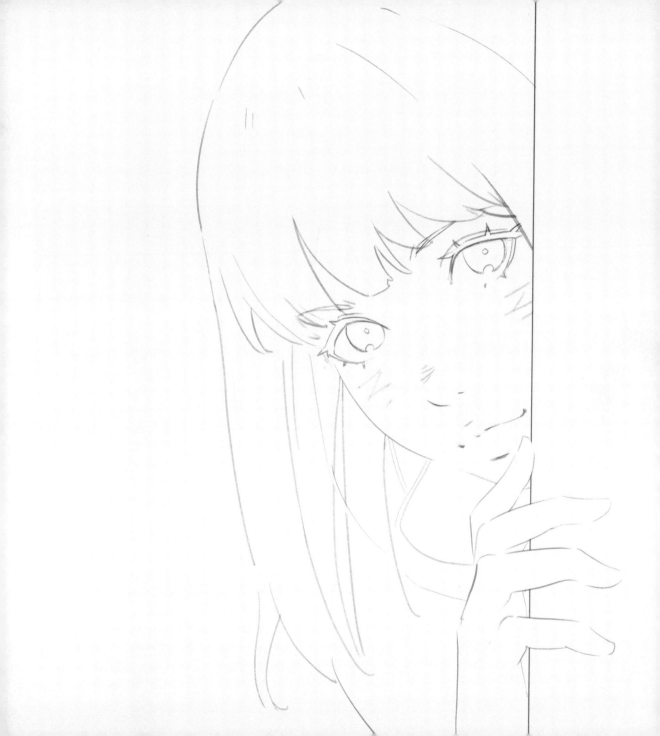

小林雅之さん、有馬トモユキさん、杵淵恵子さん、そしてこの本の出版に関わってくださったすべての方々に感謝します！

執筆に協力してくれたファティマ・カミローザに特別な感謝を。

以下のみんなに感謝します。母と父（もちろん祖母と祖父も！）。308ARTの最高なイリア、ユーリ、セルゲイ。日本に住む仲間、パーベル、ヴィタリー。ナジェージダ。そして私がこれまでに出会い、仕事をし、ともに生き、語り合ったクールなみんな。あなたたちのおかげで今の私があります。ありがとう。

Patreon.comを通して私をサポートしてくれている最高のパトロンの皆さま、ありがとうございます！

私に芸術を教えてくれた先生方に感謝します。

私をかき立ててくれるクリエイターの皆さまに感謝します。

『すばらしきこのせかい』と『イエスタデイをうたって』に感謝します。

最後にこれを読んでいるあなたへ。ありがとうございます。

Thank you,
Masayuki Kobayashi
Tomoyuki Arima
Keiko Kinefuchi
And all the people who worked on MOMENTARY for making this book possible!

Special thanks to Fatima Camiloza for editing the Foreword.

Thank you,
Mom
Dad (and also Grandmas and Grandpa!)
308ART Awesome Guys Ilia, Yuri, Sergei
Japan Neighbors Pavel and Vitaly
Nadezhda
and all those cool people I have met, worked, lived and talked with for making me the way I am now.

Thanks to my awesome patrons at Patreon.com !

Thanks to my art teachers.

Thanks to all those creators who inspire.

Thanks to "The World Ends With You" and "SING YESTERDAY FOR ME".

And thank YOU.

クブシノブ画集 MOMENTARY

2016年11月29日　初版第1刷発行

著者　　　　イリヤ・クブシノブ
デザイン　　有馬トモユキ(TATSDESIGN)
翻訳　　　　ウィリアムズ・エリカ、宮地大始(Paper Crane Editions)
編集　　　　杵淵恵子
協力　　　　小林雅之、Fatima Camiloza

発行人　　　三芳寛要
発行元　　　株式会社 パイ インターナショナル　〒170-0005 東京都豊島区南大塚2-32-4
　　　　　　　　　　　　　　　　　　　　　　　　　　TEL 03-3944-3981
　　　　　　　　　　　　　　　　　　　　　　　　　　FAX 03-5395-4830
　　　　　　　　　　　　　　　　　　　　　　　　　　sales@pie.co.jp

編集・制作　PIE COMIC ART編集部
印刷・製本　株式会社廣済堂

©2016 Ilya Kuvshinov / PIE International
ISBN978-4-7562-4846-6 C0079
Printed in Japan